Roman Art

SUSAN WALKER

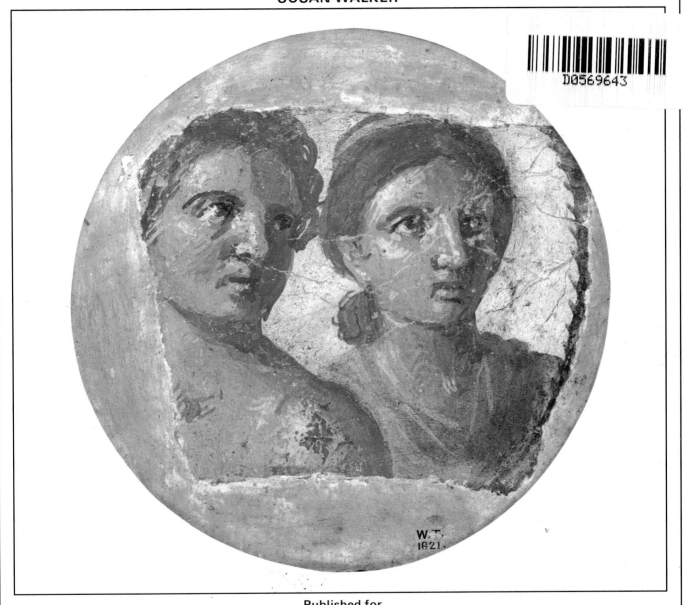

W.T.
1621.

Published for

The Trustees of the British Museum by

BRITISH MUSEUM PRESS

TF

ISBN 0-7141-2076-6

Published by
British Museum Press,
a division of
British Museum Publications Ltd,
46 Bloomsbury Street,
London WC1B 3QQ

Designed by Roger Davies
Phototypeset in Photina by
Southern Positives
and Negatives (SPAN),
Lingfield, Surrey
Printed in Hong Kong

CONTENTS PAGE Francis Towne (1739/40–1816), *The Colosseum from the Palatine*. Watercolour with pen, 313 × 464mm. Signed by the artist and dated 1781. In the foreground on the left is the Arch of Constantine. PD.1972.0.618.

PHOTOGRAPHIC CREDITS All photographs are by Philip Nicholls or from departmental archives except the following: 1, 7, 9, 50, 62 author; 6 Musei Vaticani.I.N. 74.1007; 8 Dr D. Berges; 24 Soprintendenza Archeologica di Roma, Museo Nazionale delle Terme, Rome; 43 *CTI. Attraverso l'Italia. Roma I* (Milan 1941); 46 J.J. Wilkes; 53 Museum of Antiquities, Newcastle on Tyne; 54 I.N.77.2209; 61 R. A. Jackson; 70 drawn by Sheila Gibson; reproduced by permission of Andrea Carandini; inside back cover Soprintendenza Archeologica di Napoli. Additional thanks to Chris Entwhistle, Carole Mendleson, Lindsay Stainton and John Taylor for supplying photographs from the departments of Medieval and Later Antiquities, Western Asiatic Antiquities, Prints and Drawings and Egyptian Antiquities.

**For John,
some unaccustomed
dabbling**

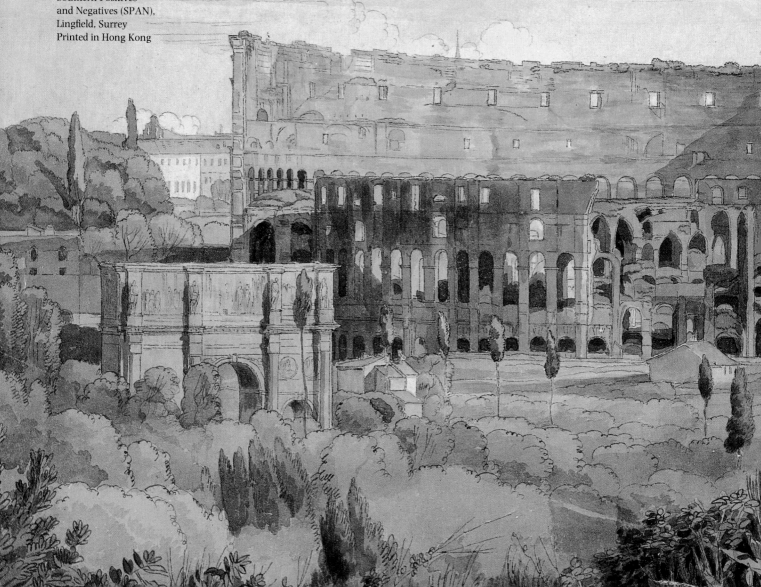

Contents

Preface page 4

Introduction 5

**1 Learning to love luxury:
the Romans and Greek art** 8

2 Roman portraits 23

**3 From Bath to Baalbek:
public art in the Roman Empire** 38

4 The Romans at home 50

Further reading 71
Photo acknowledgements 71
**List of objects illustrated
and where to see them** 71
Index 72

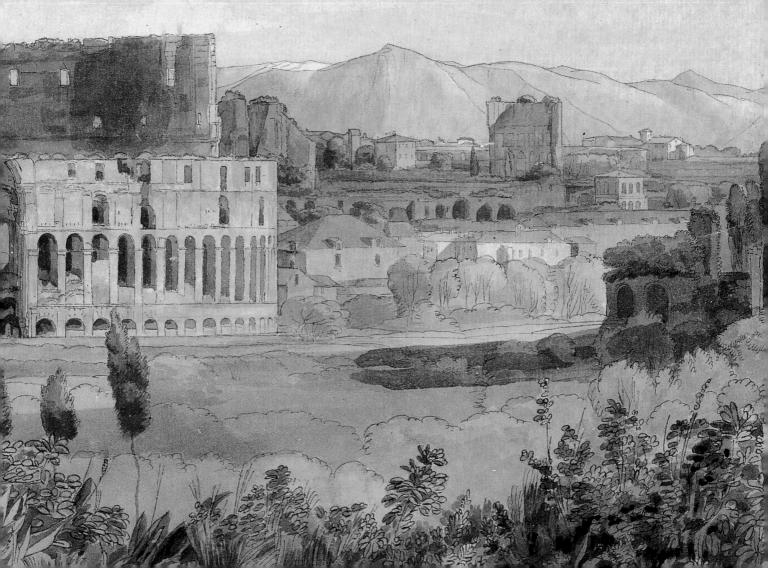

Preface

This is a very personal view of Roman art. Rather than attempt in a short book a history of artistic developments at Rome from the early days on the Palatine to the rise of the Christian city, I have chosen to write about four important themes, which are briefly described in the introduction. I have, of course, been very selective, but I hope that the book will cast further light on surviving Roman monuments and the collections of antiquities displayed in the British Museum and elsewhere.

The text has been much improved by Brian Cook, Lesley Fitton, John Wilkes, Susan Woodford, and not least my editor Jenny Chattington. Donald Bailey, Amanda Claridge, Kenneth Painter and Veronica Tatton-Brown contributed expert advice on pottery, sculpture, silver and glass. I am especially grateful to Susan Bird, Andrew Burnett, Bernard Jackson, Ralph Jackson and Philip Nicholls for providing illustrations at short notice. My thanks, too, to Andrew Brock, Kay Cummins, Ken Evans, Bill Field, Kin Overend, Derek Redford and Susan Smith for transforming bright ideas into groups of objects ready for photography; my gratitude, finally, to Hafed Walda, for organising the photographic work.

September 1990

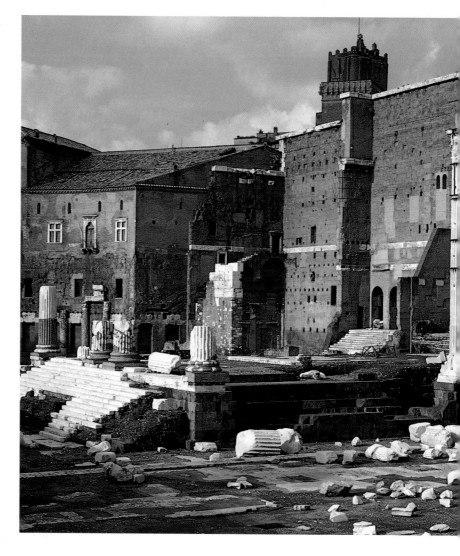

Introduction

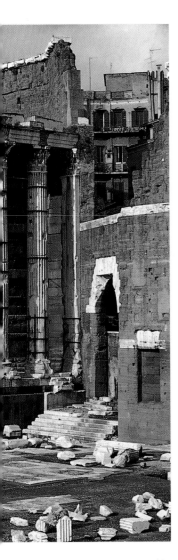

1 Part of the Forum of Augustus. In the centre, the Temple of Mars Ultor with curved bays and colonnades to either side.

From the early Republic to the later Empire the art and culture of Classical and Hellenistic Greece strongly influenced the art of the Romans. The first chapter of this book gives an historical account of how the Romans came into contact with the art of the contemporary Hellenistic world. As they conquered peninsular Italy and Sicily in the third century BC, the Romans took works of art and dedicated them to the gods at Rome. By this process they literally made the art of other communities their own. The coastal areas of southern Italy were dotted with cities occupied by the descendants of Greek colonists. The south-east lay close to Macedon, across the Adriatic Sea. Here ruled the successors to Alexander the Great (d.323 BC), who had extended Greek culture far beyond Greece to Asia Minor, Cyprus, Egypt and the Middle East. The Romans, by 200 BC masters of Italy, then became engaged in conflict with Alexander's successors throughout the eastern Mediterranean. The art of these peoples, too, was brought back to Rome, and many artists came to fulfil the demand of wealthy Romans for versions of famous works for private enjoyment.

In the first century BC Rome underwent a political revolution, which led to the collapse of the Republic and the establishment of an empire. The first emperor, Augustus (27 BC–AD 14), encouraged the revival of taste for the art of Classical Athens (fifth century BC). In the second century AD the emperor Hadrian developed a new relationship between Rome and the Greek heartlands, which allowed the culture of Classical and later Greece to flourish until late antiquity.

Throughout the period from the late Republic (first century BC) to the late Empire (fourth century AD) portraits were made, many of outstanding quality. The second chapter is devoted to them. Many convey in the physical appearance of their subjects the traditional Roman virtues of austerity and respect for authority. During the Empire these conservative traditions were brought up to date by the adoption of hairstyles fashionable at court; some individuals even imitated the physical characteristics of the imperial family. The unflattering and lively style of Roman portraits makes even the most conventional subject seem lifelike to the modern viewer.

The third chapter deals with Roman art in public places, mostly cities and sanctuaries. Of particular interest here is the very strongly developed Roman sense of *decor*, meaning not 'decoration', but the selection of a style suited to its setting. The Romans applied this principle widely in planning and furnishing cities, forts and even private houses. The sculptures and inscriptions with which the Romans embellished their cities provide a particularly valuable insight into the purpose of Roman monuments, although only a few sites are known in which buildings, statues and inscriptions survive together. These show that the Romans devised complex ways of referring in monuments, pictorially and in writing, to historical events and to ideas. When such monuments are reduced to ruins the surviving remains may appear a meaningless mixture of motifs borrowed from too many sources. But in monumental sculpture, as in gatherings of important people in real life, what matters is who stands next to whom, and what is said of them. It is, then, important to try to reconstruct monuments and understand them in their entirety. Some discussion of funerary monuments is included in this chapter; although today we may consider these private, many Romans evidently thought that the more people saw their memorial the better. It was not unusual for a direct appeal to be made in a memorial text to casual passers-by, or for visually impressive and even amusing monu-

ments to command attention from the side of a road.

The last chapter is devoted to life at home, to the organisation and use of space in the Roman house, and to its furnishings and decoration. There follows a detailed account of dining habits and tableware, in ceramic, glass and metal. I have stressed this aspect of Roman social life, because it appears from the surviving literary and archaeological evidence that the entertainment of friends at home was one of the greatest pleasures during the Empire. Moreover, tableware is the most common survival of Roman artistic products: anyone who engages in Roman art and archaeology will come across it.

For the most part these themes are well illustrated by the collections of Roman antiquities in the British Museum, and it is my general purpose to offer some historical background to the present exhibitions. It so happens that the Roman collections, which cover a geographical area from Britain to the Middle East and North Africa, fall within the interests of several departments of antiquities. Roman Britain, for example, is part of the Department of Prehistoric and Romano-British Antiquities, an arrangement which emphasises the continuity of settlement in this country, but implies that British antiquities are exhibited separately from their European counterparts. Such a division is of no little interest today, as politicians debate the extent of European political and economic union, and of Britain's involvement in Europe. It is no coincidence that the areas of greatest prosperity in late twentieth-century Britain correspond to the civil area of the Roman province: at no time since the withdrawal of the Romans from Britain in AD 410 has the economic and political relationship with continental Europe been so close.

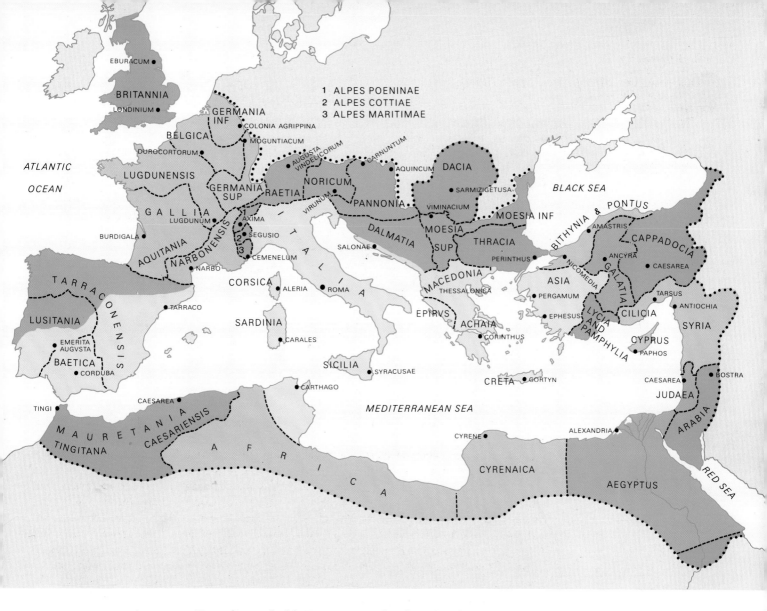

Map 1: the growth of the Roman Empire. The colours show the gradual acquisition of territory, first in the Mediterranean heartlands and later in continental Europe. The boundaries show the Empire and the provinces as they were organised in the 2nd century AD.

1 Learning to love luxury: the Romans and Greek art

The art of the Hellenistic world presented a profound moral difficulty for the Romans of the Republic. The elegant refinement of Hellenistic art conflicted with Roman ideals of austerity and a simple style of life. But as Rome became first an Italian and then a Mediterranean power, it became inevitable that the Roman people should have contact with Greeks and with Greek art. Much of the history of early Roman art reflects the tortured relationship of the (ideally) austere conquering power to its (supposedly) decadent but culturally superior vanquished subjects. The contradictions were not completely resolved until Greek culture was fully accepted by the Roman emperor Hadrian and his court (AD 117–38).

The earliest displays of Etruscan and Greek art in Republican Rome were seen at the triumphal parades of loot and prisoners held in the centre of Rome to celebrate the victories of Roman consuls, senior magistrates who led the army into battle. The art was looted from conquered cities in Etruria, to the north of Rome, and from the Greek communities of southern Italy. Such spectacles were not likely to encourage an educated view of the treasures displayed. The Roman people liked

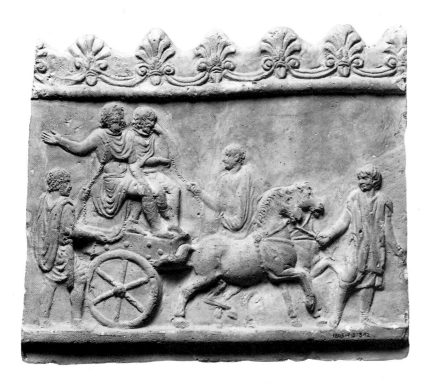

3 (*Above*) Prisoners from Dacia in an imperial triumphal parade. Terracotta plaque, early 2nd century AD.

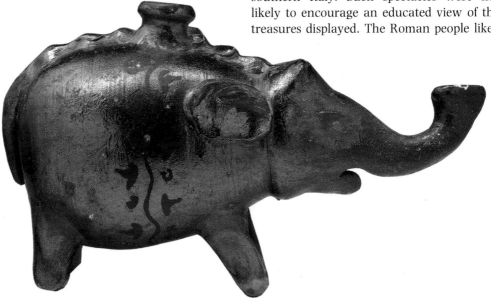

4 (*Right*) Vase in the form of an elephant. 3rd century BC. From Vulci, Etruria.

triumphal parades to be entertaining. In this respect they considered elephants, brought to Rome as exhibits from the Punic Wars against Hannibal, superior to works of art and fine craftsmanship. The taking of booty from conquered cities was called by the Romans *deditio* (surrender), a process in which captured weapons, money, works of art or other valuables were dedicated to the gods at Rome, thereby giving divine sanction to the imposition of Roman rule.

Wars with the Samnites to the south (343–290 BC) opened contacts with the Greek communities of southern Italy. The fall of Tarentum in 272 BC and the ravages of the wars of the Romans against Pyrrhus of Epirus, conducted in south-east Italy, led to the decline of the Greek cities of southern Italy and Sicily. Pliny perhaps had this in mind when he wrote that art ceased in 296 BC. Archaeological evidence points to a slightly later break, with a gap in the production of fine pottery, paintings and metalware from about 250 to 210 BC. It may also be argued that Roman military advances effectively changed the artistic map of Italy. Roads built to reach newly founded Roman colonies and to transport armies bypassed long-established cultural centres, leaving them to decay. Other new centres were to flourish.

The horizons of Roman taste were revolutionised by Marcus Claudius Marcellus' sack of Syracuse, the last independent city of Sicily, in 211 BC. Syracuse had long been ruled by tyrants who patronised the arts and sciences. The booty included paintings and statues and two astronomical globes, the work of Archimedes. According to Plutarch, writing in highly refined Greek circles in the early second

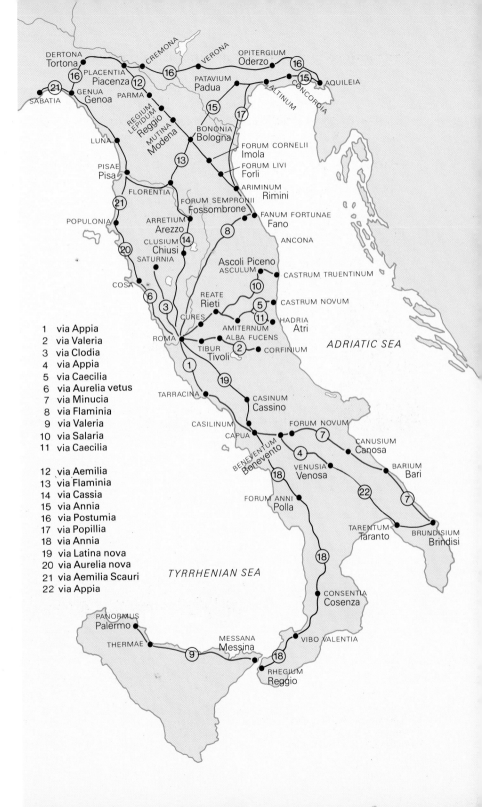

1 via Appia
2 via Valeria
3 via Clodia
4 via Appia
5 via Caecilia
6 via Aurelia vetus
7 via Minucia
8 via Flaminia
9 via Valeria
10 via Salaria
11 via Caecilia

12 via Aemilia
13 via Flaminia
14 via Cassia
15 via Annia
16 via Postumia
17 via Popillia
18 via Annia
19 via Latina nova
20 via Aurelia nova
21 via Aemilia Scauri
22 via Appia

Map 2

Map 2: map of roads built in Italy during the 3rd and 2nd centuries BC.

century AD: 'Before this, Rome neither had nor even knew of these exquisite and refined things, nor was there in the city any love of what was charming and elegant; rather, it was full of barbaric weapons and bloody spoils.' Marcellus met with opposition from conservative senators, who accused him of making Rome the object of envy, and of corrupting the populace with a taste for leisure and idle chat. Marcellus' defence was that he had taught the ignorant to respect and wonder at the beautiful and marvellous works of Greece (*Marc.* 21).

In 209 BC spoils arrived from the Greek city of Tarentum, in south-east Italy. Quintus Fabius Maximus, who punished the Tarentines for going over to Hannibal during the Second Punic War, found the colossal bronze Zeus, the work of the famous sculptor Lysippus, too difficult to transport to Rome. But another work by Lysippus, showing the hero Hercules purging the Augean Stables, was exhibited in Rome next to a statue of the triumphant Fabius Maximus on horseback. In the fourth century AD the statue of Hercules was removed to the new capital of the eastern Roman Empire, Constantinople, which became a museum of ancient art (the snake column from Delphi may still be seen in the Hippodrome). Evidently the need to furnish an emerging capital with prestigious works of art remained important throughout antiquity and indeed in more recent times: Rome lost much, though temporarily, from Napoleon's ambitious plans for embellishing Paris with famous works of art, and during the Second World War many artistic works were transported from Italy to Germany.

By the end of the third century the process of *deditio* of works from Italian cities was complete. The first acquisitions of booty from Greece itself came from the campaigns of Lucius Quinctius Flamininus against Philip V of Macedon in 198–197 BC. Rome subsequently became involved in wars containing the expansionist policies of the Seleucid monarchs of Syria.

Contemporary dedications at Rome reflected the growing trend of relatives of military commanders to glorify their illustrious ancestors, a trend also seen in portraiture (see chapter 2). There was also a growing tendency to retain a certain amount of booty for personal use. Lucius Cornelius Scipio, brother of Publius Scipio Africanus who was famed for his victory over Hannibal in Africa, defeated Antiochus III of Syria at the Battle of Mag-

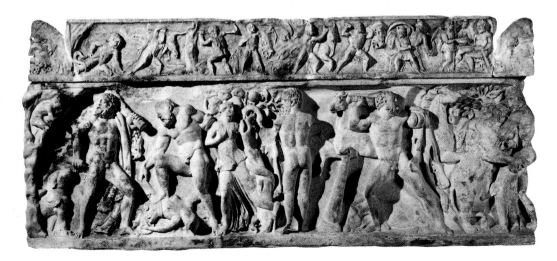

5 Sarcophagus decorated with the Labours of Hercules. The figures are thought to have been adapted from a cycle of statues made by the sculptor Lysippus for a sanctuary at Alezia (Acarnania, Greece) in the 4th century BC and later brought to Rome. Made in Rome about AD 150–70.

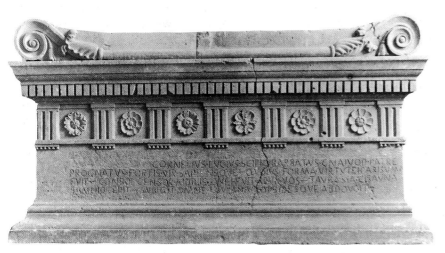

6 Sarcophagus of Lucius Cornelius Scipio Barbatus. Made in the early 3rd century BC. The inscription was added later, and the order of the consul's names was then reversed. Vatican Museums.

nesia in western Asia Minor in 189 BC. In his triumphal parade Scipio (known as Asiaticus) displayed gold, ivory, silver, money and bronzes. He also brought Greek artists to Rome, and was himself portrayed dressed as a Greek in cloak and sandals in a statue dedicated on the Capitol, where paintings of his campaigns were displayed. The Tomb of the Scipios, the ruins of which still survive by the Via Appia south of Rome, offers ample evidence of the early and long-lasting adoption of Greek values by this noble Roman family. A later epitaph carved on the sarcophagus of Scipio Africanus' ancestor, Lucius Cornelius Scipio Barbatus, described him as having 'good looks equal to his valour', an idea foreign to traditional Roman thought but very much in the tradition of Alexander of Macedon. Indeed, Scipio Barbatus' sarcophagus, made in the early third century BC of local stone, resembles a contemporary Greek altar. The very notion of burial in a sarcophagus was alien to Republican Rome, where most individuals were cremated.

Furniture, carpets and musical instruments made an appearance in the triumphal parade of Gnaeus Manlius Vulso (consul in 189 BC),

victor over the Gauls in Asia. Though depleted by robbery in Thrace on the way home, Vulso's loot astonished the Romans for its size and quality. Until late antiquity Vulso's triumph remained a byword for luxury. Pliny the Elder, writing in the later first century AD, says that about the time of Vulso's triumph statues of wood and terracotta ceased to be used at Rome and were replaced by *luxuria* from Asia Minor. These were, no doubt, the products of the many Greek artists who were brought to Rome at this time.

On 22 June 168 BC Lucius Aemilius Paullus defeated King Perseus of Macedon at the Battle of Pydna. In 167 he celebrated a three-day triumph. The wealth accruing to the treasury was so great that the citizens of Italy were henceforth relieved of the need to pay tribute. Much of the booty consisted of works of art, including a statue of Athena by Pheidias, displayed by Paullus in the temple of Fortuna. The painter and philosopher Metrodorus was brought from Athens to record the story of the triumph and instruct Paullus' son. There are other indications that the great general had a personal interest in Greek art. When Paullus saw at Olympia the gold and ivory statue of Zeus by Pheidias, he declared he felt himself in the presence of a god. Most significantly, he took over a monument in the great sanctuary at Delphi, previously intended to commemorate his vanquished opponent Perseus. On the upper register of the monument was an ambitious if small-scale scene of battle, now reworked to show Paullus' victory at Pydna. Paullus himself may appear as one of the Roman riders. An inscription on the base confirms the new destiny of the monument.

Of prime importance for the history of Roman attitudes to Greek art are the activities of Paullus' successors, Quintus Caecilius Metellus (later named Macedonicus for his victories in Macedonia) and Lucius Mummius. In his triumphal parade at Rome Metellus

7 The imperial façade of the Porticus of Octavia, Rome, a redevelopment of the monumental colonnaded enclosure built by the distinguished admiral Cnaeus Octavius in 168 BC.

showed a group of thirty-four bronzes by Lysippus, court sculptor to Alexander the Great. The Macedonian ruler and his fellow soldiers were portrayed fighting the Battle of the Granicus. The bronzes were later set up in the Porticus Metelli, the first secular building in Rome specifically intended for the display of booty. The portico formed part of a complex of buildings linking the temple of Juno Regina, restored by Metellus, and the temple of Jupiter Stator, possibly the first marble temple in Rome, designed by the Greek architect Hermodorus of Salamis in Cyprus at the invitation of Metellus. Here, too, were probably housed the statues of Aesculapius and Diana by the Greek sculptor Cephisodotus.

In 146 BC, acting on a senatorial decree,

Metellus' colleague Mummius sacked Corinth, the richest city of Greece. The looting that ensued was the most notorious act of plunder in the history of the Republic. The historian Polybius, a witness, reported that soldiers used the works of the painter Aristides as gaming-boards. One of these paintings was later spotted by the Greek geographer Strabo in the temple of Ceres at Rome. He says it was burned shortly afterwards. The painting, which represented the god of wine, Dionysos, might have had a happier fate had Mummius agreed to the bid of 100 talents made for it after the sack by King Attalus of Pergamum, but Mummius was intent on taking his booty to Rome. The plunderer of Corinth did not belong to one of the old noble families of Rome, and attracted

numerous sneers from the Roman intelligentsia. That much is clear from the standard of his labels; he would have made a poor museum curator! A statue of Poseidon of Isthmia was labelled as Zeus, and a portrait representing Philip II of Macedon as Zeus was described quite simply as Zeus. Two portraits of Greek youths were mistakenly labelled Nestor and Priam. The surviving accounts of his triumph dwell on the size of the booty, but of greater interest to us is its dispersal: statues were dedicated in Italian and even in Spanish towns, where Mummius had earlier served as *praetor* (judicial magistrate) and provincial governor. Mummius made some amends to the Greeks by generous dedications in their sanctuaries.

Greece was to suffer a further blow half a century later with the rise of Lucius Cornelius Sulla, Dictator at Rome in 82–1 BC. Declared an enemy of the Roman state in 88 BC, Sulla was granted no funds for his campaigns against King Mithradates of Pontus, in northwest Asia Minor. Consequently, he plundered the sanctuaries of Delphi, Epidaurus and Olympia, and gold and silver were collected throughout the Peloponnese to be melted down for coin to pay his armies. In 86 BC Sulla plundered Athens. The centre of the city did not fully recover for nearly two centuries. Even the uncompleted temple of Olympian Zeus was robbed of some columns, taken for the temple of Capitoline Jupiter at Rome.

Sulla's successor in the eastern command, Lucius Licinius Lucullus, became a byword for luxury and personal indulgence. Concentrating on Mithradates' home ground, he stripped the Pontic cities of their art treasures. Both Lucullus and his successor Pompey displayed works of art that were the property of the royal house of Pontus, emphasising the crushing of the dynasty by Rome.

Misappropriation of plunder was punished. The most famous surviving account of this is the prosecution of Verres, *pro-praetor* (a governor with the authority of a Roman judge) in Sicily from 73 to 70 BC. During his prosecution by Cicero Verres fled to Marseilles, but appeared again on the proscription list of Mark Antony, compiled in 43 BC, thirty years after Verres' term of office. Verres had not yet handed to the state his collection of Corinthian bronzes.

Following the defeat of Antony and Cleopatra at the Battle of Actium in 31 BC Julius Caesar's great-nephew and heir, Octavian, became master of the Mediterranean world. Actium, and Octavian's victory in Egypt the following year, provided the occasion for the last great triumph in the Republican style. Egyptian jewellery adorned the statue of Victory long since looted from Tarentum in southern Italy and displayed in the Curia Julia, named after the Julii, Octavian's family. A gold statue of Cleopatra was paraded at the triumph; this was later displayed in the temple of Venus Genetrix, a patron deity of the Julii. The obelisks now adorning the Piazza del Populo and the Piazzo di Montecitorio in the centre of Rome were brought by Octavian from Egypt. They were first displayed in the Circus Maximus and the Campus Martius by the Tiber. To suggest continuity between himself and the triumphant generals of the later Republic, Octavian reconstructed all the buildings in the area of the Porticus Metelli, where their booty had been displayed.

In 27 BC Octavian took the name Augustus, offered to him by the Roman Senate. Though he claimed to have restored the Republic after thirteen years of civil war that lasted from the murder of Julius Caesar in 44 BC to the Battle of Actium in 31, he was in fact sole ruler and emperor of Rome and its conquered territories. As emperor, Augustus gave financial compensation and some booty back, though it must be said that such acts of generosity were inspired less by guilt than by political revenge against

8 The Obelisk of Augustus from the Circus Maximus in the Piazza del Populo, where it has stood since 1589.

cities that had supported his rival, Mark Antony: the returned booty was Antony's plunder. Augustus kept his own, and, moderating the custom of his Republican predecessors, displayed some publicly while reserving a few items for private enjoyment. Thus an ivory statue of Athena Alea from the famous sanctuary at Tegea in the Greek Peloponnese was set at the entrance to his Forum, while a tusk of the Calydonian boar – no doubt correctly labelled – passed into the emperor's bone collection. Both items were reported 150 years after Augustus' death by the traveller Pausanias (8, 46, 5), who says that the 'keepers of the wonders' note that one of the boar's tusks is broken while the surviving tusk is kept in the Emperor's Gardens in a Sanctuary of Bacchus and it measures just three feet long.

Until well into the reign of Augustus the display of Greek art in Rome was more closely linked to political advancement and military might than to religious belief and aesthetic appreciation. It is very characteristic of the Romans that they chose to display in public parades those objects considered particularly suited to the context in which they were won – gods and heroes were explicitly linked to the glory of battle. There were currents of opinion at Rome, represented by the Elder Cato and, much later, by Augustus' lieutenant, Marcus Agrippa, that favoured the restriction of the display of booty to public settings. These arguments were directed against the corrupting accumulation of astounding wealth by private individuals, and aimed at bolstering the prestige of Rome as the most powerful state in the Mediterranean world. The city of Rome had to appear worthy of its position. There was, of course, a conflict between the traditional right of generals to dispose of their plunder as they saw fit, by rewarding themselves, their relatives and supporters, and their obligation to the state to supply money and the visible trappings of power. From 19 BC none

but the emperor was permitted to enjoy a triumph, and victorious generals had to be content with the nominal honours of the *ornamenta triumphalia*. With the onset of empire, the conflicts of interest between state and individual, and between luxury and austerity, were subsumed by the power of the emperor to embellish the city and court as he wished.

Greek art and artists at Rome

In the later Republic and early Empire Greek artists were brought to Rome to design buildings appropriate for the display of booty, to repair old sculptures and make new ones for these and other structures, and to restore decaying old temples, once venerated for their wooden and terracotta statues, but now seen to be in need of renovation. Naturally, the public display of great works of art led to a demand for imitations for enjoyment by wealthy individuals. At the same time a taste arose for the refined lifestyle of the cultured Greek. Some members of the Roman aristocracy became exceedingly Hellenised, but particular aspects of Greek culture met with resistance from the more conservative elements of Roman society. No permanent theatre was permitted in Rome until that built by Pompey in the mid-first century BC. A decree of the Senate was passed in 186 BC, ordering the destruction of sanctuaries of Bacchus, the god of wine (Greek, Dionysos), and banning his worship, but the growth of the Italian wine trade and the personal involvement in it of many of Rome's leading senators ensured the god's recovery. A great wave of Greek influence in Rome began in the mid-second century BC with the conquest of Greece, and lasted well into the first century, by which time it had become a well-established fashion for young men of well-to-do families to complete their education in Athens. Indeed, artistic traffic was not only in one

9 The Temple of Olympian Zeus, Athens, a project begun in the late 6th century BC by the Athenian tyrant Pisistratus. Most of the standing remains date to the 2nd century BC.

direction. Some Greeks who favoured Rome adopted a Roman style of portrait. In 174 BC the Roman architect Decimus Cossutius, son of Poplius, worked on the construction of the temple of Olympian Zeus at Athens, a project sponsored by the Seleucid king Antiochus IV. The huge temple, begun at the close of the sixth century BC by the Athenian tyrant Pisistratus, was finally dedicated by Hadrian in AD 131–2. Most of the standing remains date to the second century BC.

Greek artists of this period were highly mobile, and this is reflected in the development of a well-defined style dispersed over a wide geographical area. Generations of artists travelled about the Mediterranean. Thus in the later second century BC the sculptor Timarchides worked with his brother Timokles on various commissions, including a statue of Apollo in Rome. His nephew, also called Timarchides, worked with the elder Timarchides on the Greek island of Delos, where he

sculpted a portrait of the Roman businessman Gaius Ofellius Ferus. Some sculptors were quick to take advantage of gullible Roman collectors new to the game. A Rhodian, Menodotus, collaborated with another Rhodian to forge a bronze statue of Apollo and pass it off as a work of the early fifth century BC.

It was not uncommon for craftsmen to excel in a variety of media. Pasiteles was a famous sculptor of the first century BC who founded a school at Rome. He was probably a Greek from southern Italy. Pasiteles was skilled in working stone and bronze, but was especially talented at metalwork and at modelling from life. Works signed by members of his school survive, and indicate that Pasiteles and his pupils specialised in creating works in the 'severe' style of early Classical Greece. Pasiteles is known to have made an ivory image of Jupiter for the temple of Jupiter in the complex of buildings developed by Metellus Macedonicus. His career was not without personal risk:

the sculptor was nearly mauled in the dockyards at Puteoli while drawing caged animals destined for the arena.

It is clear from the surviving works by Pasiteles' pupils that, though they were famed as copyists, their copies of famous works were in fact rather free adaptations. There are a number of possible reasons for this. The demands of the collector, with the need to consider the setting and purpose of a copy, contributed to the distancing of Roman copy from Greek original. In addition, the Greek sculptures displayed in Rome had been removed from their intended context, and were therefore reproduced without reference to it. Moreover, most surviving copies are made of marble, which does not perform as bronze.

It used to be thought that as the practice of copying became more common the Romans devised an instrument similar to the modern pointing machine for making exact reproductions. The modern instrument consists of a fixed frame with adjustable rods. Three basic points are fixed on a plaster model of the original and on the marble block, and the frame transferred back and forth from model to block, each point being marked by drilling a hole to the required depth. If sufficient measurements are taken, this is a very accurate way of making a copy. However, though plaster models are known from antiquity, no certain traces of the use of a pointing machine have yet been found on Roman copies. (It is only too easy to drill the holes slightly too deep, leaving tell-tale 'points' on the surface of the finished sculpture). Roman sculptors appear to have made use of only a few set measuring points, which sometimes survive, raised off the surface like pimples. From these other points could be measured by triangulation with compasses or calipers. It is difficult to achieve truly three-dimensional accuracy with this method, but mathematical precision was not a prime requirement in Roman commissions, most of which were intended to be displayed in a setting with a restricted angle of view. As in Roman portrait sculpture, so in copies of statues of deities and other figures the element of recognition was provided in the head. This is where the sculptor might be expected to remain close to the original, though even here a Roman preference can be detected for a certain shape, or for an angle that increases the sentimental value of the copy.

10 Two figures of Pan, signed by the sculptor Marcus Cossutius Cerdo, freedman of Marcus. From the site of a villa near Civita Lavinia, Italy. 1st century BC, and extensively restored in the eighteenth century.

Most Roman sculptors were very cautious about supporting large blocks of marble. Many statues were bolstered by struts that now appear unsightly, especially in comparison with unsupported bronze statues. Some sculptors dealt with the problem by making the support part of the narrative, decorating it with features that helped to identify the figure. Others designed the sculpture for a specific viewpoint, which can sometimes be reconstructed by looking up into the figure's eyes. Most Roman statues were displayed in niches, which necessarily limited the angle of view. It was then possible to hide structural supports by aligning a figure suitably within a niche. It should also be borne in mind that ancient marble statues were painted. Paint, too, played a useful role in disguising ugly struts.

In marked contrast to their taste in portraiture (see chapter 2), it seems that many Roman collectors preferred youth, physical beauty and sentiment to the reality of Greek originals. They went for small-scale figures, often made to appear more youthful than the subject allowed. The 'Westmacott Youth', named after the nineteenth-century collector and sculptor Richard Westmacott, is a case in point. This is a copy in Parian marble of a bronze statue by the fifth-century Argive sculptor Polyclitus, whose works were much admired in imperial Rome. The original, although it is hard to believe from the fragile beauty of the copy, represented a boy boxer, Cyniscus of Mantineia, whose feats were commemorated in a bronze statue set up in the sanctuary at Olympia. In the marble version the struts have been banished from sight by designing the statue to be seen from a restricted viewpoint. We may suppose that it originally stood in a niche. The shape of the head has been sharpened, the overall aspect of the figure softened and sentimentalised.

Polyclitan youths, the bread and butter of the Roman sculptor, came in three sizes: *pais*

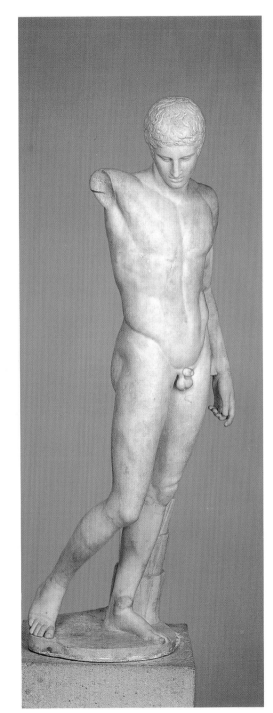

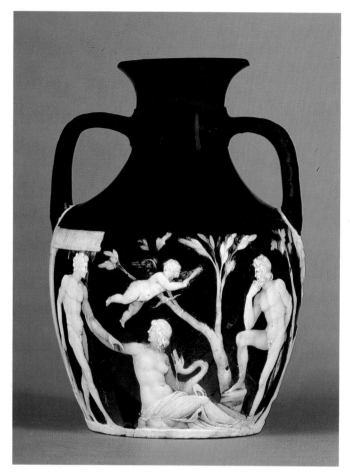 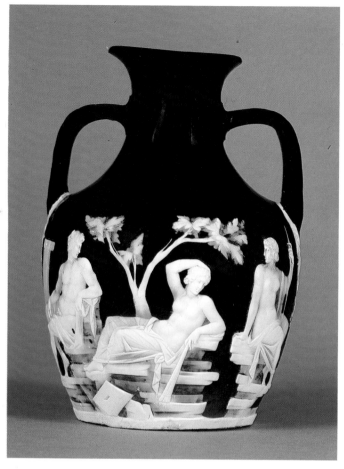

12 (*Above*) The Portland Vase: scenes of love (*left*) and loss (*right*), probably taken from a mythological subject. Cameo glass made in Italy in the early 1st century AD.

(child: 1.10m); *ephebe* (youth: 1.50m); *neos* (mature youth: 1.86m). In the last category fell four types that embodied the ideal qualities of physical form as set out in the 'canon' of Polyclitus: the *diskophoros* (discus-carrier), the *doryphoros* (spear-carrier), the *diadumenos* (victor crowning himself) and the hero Hercules. The second, it has been argued, formed the basis of the portraits of Augustus, and in that capacity the *doryphoros* achieved heroic proportions. But it was more customary for the copyist to reduce the proportions, turning *diadumenoi* into *ephebes* to please the client's personal tastes and fit well into the dining-room. This last point may be appreciated by visiting the Townley Room in the British Museum (Room 84). Charles Townley (1737–1805) collected Roman sculpture rather as a Roman connoisseur would have done, with a view to making a cultured ambience at home, well suited to his intellectual interests. Standing in the Townley Room and looking through to the sculptures displayed next door (Room 83), most of which were intended for public display, one is well aware of the reduced scale and decorative qualities sought by the private collector who wined and dined amidst his collection.

Augustan classicism

The age of Augustus saw a formidable interest in the Classical period. On some objects scenes were reproduced whose precise meaning is difficult to recapture. The Portland Vase is a good example of the genre. The most exquisite surviving example of cameo glass, it is decorated with two scenes, evidently connected with each other and concerned with love and loss. Much scholarly debate has arisen over the identification of the figures and the interpretation of the scenes. Those who favour a depiction of the fortunes of the imperial house have to reckon with the difficulty of recognising Augustus. Recognition is so fundamental to Roman imperial portraiture that any doubt over the mortal identity of a figure should indicate that the scene is not concerned with important people.

We may see in the modern confusion surrounding the Portland Vase a tendency, particularly marked in later works of the Claudian period (AD 41–54), to liken idealised figures to portraits. There are two good examples of this in the British Museum's Roman sculpture collections: the 'Spinario', a boy removing a thorn from his foot, and 'Clytie', long taken to be a portrait of the emperor Claudius' mother, the younger Antonia, but perhaps better identified as a personification of one of the nations defeated by Augustus. The 'Spinario' is clearly based on a genre figure, one of the studies of everyday life so popular in the later Hellenistic era, but his hair and features reflect fashions in Claudian portraiture. Both 'Clytie' and the 'Spinario' are very popular with modern museum visitors, reflecting the appeal that such works undoubtedly had to the Roman connoisseur.

Another striking characteristic of Roman art of the first century AD is the adoption for private use of motifs originally intended for public monuments. This tendency is also apparent in the design and decoration of

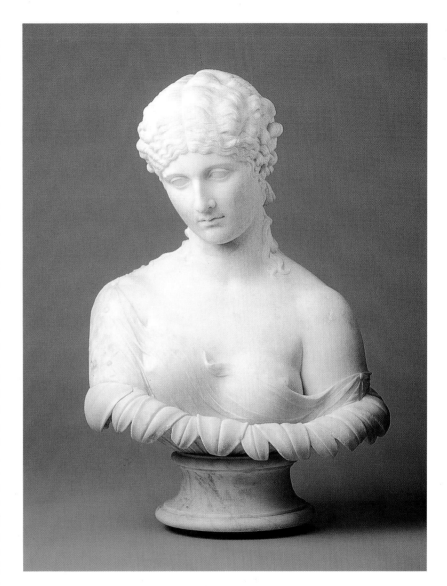

13 'Clytie'. Marble bust, possibly representing one of the peoples conquered by Augustus. Made about AD 40–60.

Roman houses (see chapter 4). It may be that the use of imperial motifs was thought to bring good fortune. The imperial eagle and the personification of Victory are obvious examples of symbols of imperial power, but they turn up with surprising frequency upon ornamental furniture, lamps and, most notably, 15 funerary monuments. Private citizens were also quick to adopt the more decorative motifs of imperial monuments. The famous acanthus scrolls decorating the *Ara Pacis* (Altar of Augustan Peace) were reproduced at every 86 scale and in many media. It seems that the reforms and the taste of Augustus extended to every area of political and social life, and 'the empire style' was enthusiastically adopted, not least by the 'upwardly mobile' classes, newly enfranchised by the first emperor.

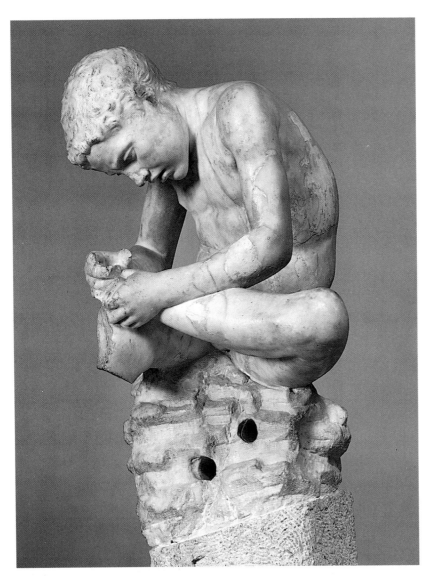

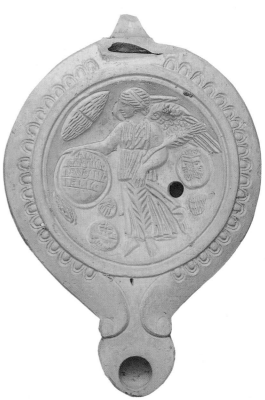

14 The 'Spinario' (boy removing a thorn from his foot). Marble version of a Hellenistic genre figure, made about AD 50. From Rome.

15 (*Right*) Victory on a Roman lamp, with a palm branch and inscribed shield. Here imperial symbols are used to mark the New Year; seasonal gifts appear in the background. Made in Italy. AD 50–100.

The Hadrianic Greek revival

It has been well observed that classical revivals tend to be of short duration. They incline to the academic, the exclusive, the theoretical and the pedantic. By the middle of the first century AD a less restrained taste prevailed in idealised art as in portraiture. An obsession with the Classical past was to return under the emperor Hadrian, who took a deep personal interest in the fortunes of Greece and eagerly adopted a Greek appearance. The earlier taste for Greek art had been associated with the enjoyment of *otium*, the life of pleasurable contemplation indulged in by those sectors of Roman society with no need to work. By the second century AD such refined tastes had spread to a wider public. Many cities, even in provinces as distant as Britain, were now equipped with public buildings and these were filled with sculptures fulfilling the ever-important cri-

16 Marble relief: a youth restrains a horse. Made in the early 2nd century AD, imitating the Classical style of Athens in the mid-5th century BC. Found in the Villa of Hadrian at Tivoli, near Rome.

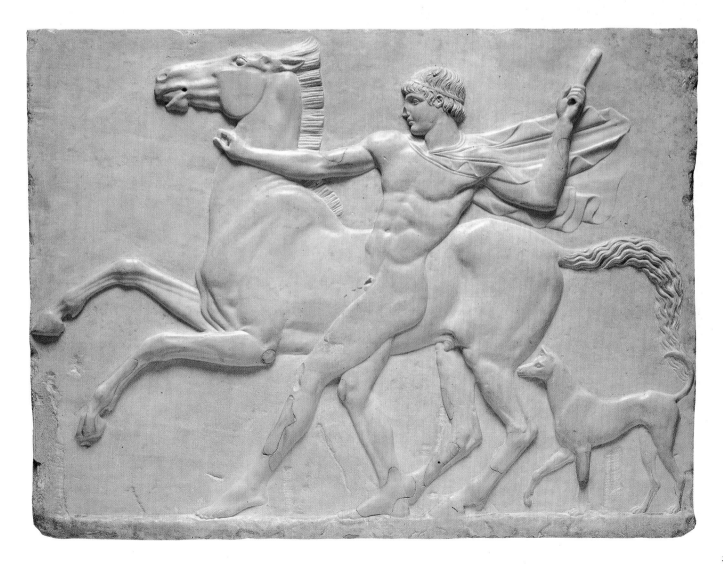

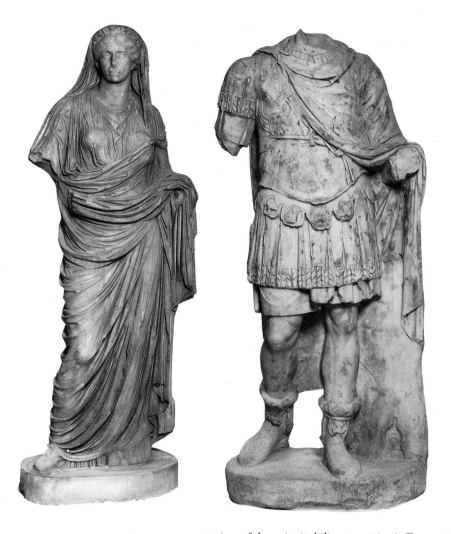

Greece, noting the state of preservation of Archaic and Classical originals missed by Roman looters, including indiscriminately works in precious materials and venerated wooden idols. Contemporary achievements, with the notable exception of the gifts of Hadrian, were largely ignored.

Such antiquarian interest in the past laid a rather deadening hand upon contemporary sculptors. The extraordinary growth in public commissions, almost all destined for display in niches cut into the walls of huge buildings, increased the existing tendency to restrict viewpoints. Advances in the organisation of manpower at the marble quarries allowed the transport of huge blocks of stone, which enabled sculptors to make large statues in one piece. In some ways sculptors became more adventurous, creating figures of larger scale and with more expansive poses than would have been tried in the first century. But the delicacy of small-scale work, and the demands upon skill made by the need to join exactly the pieced works of the early Empire were diminished.

The passion for Greece was by no means restricted to wealthy art collectors, antiquarians and professors of rhetoric. The Roman Empire was itself more acceptable to provincial subjects than had been the case in the age of Augustus, and the emperor's taste for Greek art, well publicised by Hadrian's zest for provincial travel, therefore enjoyed wide support. The broadly based Hadrianic Greek revival thus proved long lasting, and exerted a profound influence on the art of later antiquity. The taste for Greek culture also influenced the personal appearance of individuals and fashions in burial; it is particularly apparent in portraiture, even of people of modest origin.

17 (*Above*) Statue of a priestess from Atrapaldo, southern Italy. The figure is carved from a thin slab of Carrara marble. The forearms were added separately. Made about AD 20–40. Height 209cm; width 82cm; thickness 52cm.

18 (*Above right*) Statue of a Roman emperor, from Carthage. The figure is carved from a huge block of Parian marble. 2nd century AD. Preserved height 211cm; width 100cm; thickness 75cm.

terion of *decor* (suitability to setting). To meet the demand, the marble trade from quarries largely owned by the emperor was rationalised. By the end of the second century AD marble veneer and sculptures from Greece and Asia Minor were shipped as far as London.

With Hadrian we reach the second great age of Roman interest in Classical Greece. The mid-second century saw a passionate interest in the exact reproduction of Classical Greek speech. Archaism was the fashion of the day: the Asiatic Greek traveller Pausanias roamed

2 Roman portraits

From the later Republic onwards there is no period of Roman history lacking fine portraits, and it may be argued that the lack of earlier survivals is merely due to chance. Indeed, the portrait must be considered one of the outstanding Roman contributions to the visual arts. The Romans were interested in conveying aspects of individual character as these were reflected in personal appearance. It was not a Roman tradition to commemorate youth or physical beauty, so Roman portraits, of the 'warts and all' school, appear to modern eyes reassuringly true to life and easy to understand.

Portraiture in the Republic

There came to exist in Roman as in Greek portraiture a visual code in which expression was given to moral qualities. Portraits of Greek philosophers and city fathers, mostly devised in the fourth century BC and often highly individualised, had expressed admiration of their subjects' asceticism, their seniority and wisdom. Such portraits were far removed, in appearance and in the moral authority they were intended to convey, from contemporary images of the Macedonian kings who then ruled the Hellenistic world: royal portraits suggested the physical attractions and hopes of youth.

Roman portraits of public figures emphasised their subjects' fitness to hold public office and their personal authority as heads of families. More specifically, Roman portraits embodied a set of virtues traditionally valued by the Roman people. These comprised a respect for the old, for those in positions of authority and for austerity of manner and appearance. Though evidently similar to the moral values of certain Greek philosophers,

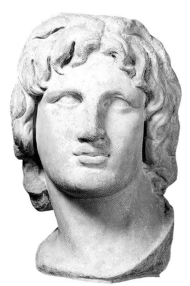

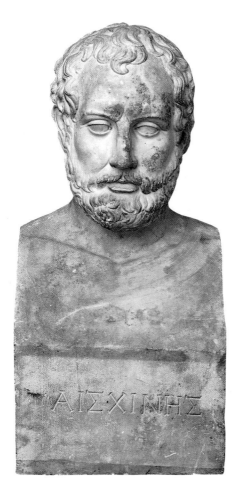

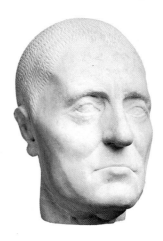

19 (*Right*) Inscribed portrait of Aeschines, the Athenian orator accused of treachery in an embassy to King Philip of Macedon (346 BC). Roman copy of a Greek original, found in Bitolia (Macedonia).

20 (*Above*) Head from a statue of Alexander the Great (d. 323 BC). A copy, probably made in the first century BC, from Alexandria.

21 (*Above*) Portrait of a Roman in the traditional Republican style. Made about 60–40 BC.

these virtues were considered typically Roman. This is apparent in a striking passage of the *Histories* (6,53–4) written by Polybius, a Greek exiled to Rome in the second century BC. Polybius comments on the quaint customs of the Romans, who had wax death-masks made of their ancestors. The masks were worn at funerals by young men of the family who bore the nearest physical resemblance to the subjects of the wax portraits. The purpose of this exercise, verbally repeated in funeral orations, was to instil in the young the duty of living up to the glorious achievements of their forefathers. This was a means of strengthening the family group and, in a political sense, the grip of a small number of families upon public life. The tradition, surely of primitive origin, proved remarkably long-lived. In the rise to power of individuals in the closing decades of the Roman Republic many magistrates advertised their right to office by reminding the populace of the virtues of their ancestors through portraits reproduced on the coins they were authorised to mint. Some of these ancestors were indeed remote: Marcus Claudius Marcellus, consul in 222 BC (and another four times) was portrayed on a coin of his homonymous descendant in 50 BC. Though of miniature format, portraits on coins and gems could be impressively characterised: witness the image of Gaius Antius Restio, Tribune of the People in 71 BC and portrayed on a coin of his descendant minted in 47 BC, or an unknown man whose authoritative portrait was brilliantly engraved in chalcedony. The Republican tradition lasted into the Empire: ancestor portraits were carried at the funerals of early imperial princes and notables, and both the imperial family and the surviving nobility continued to stress, and indeed enhance, their origins and virtues.

Scholars have long debated the origins of Roman portraiture and the influence of the contemporary Greek world upon the appearance of the portraits of individual Romans. The earliest surviving portraits are almost exclusively of the first century BC. Roman generals who campaigned in the Greek-speaking eastern Mediterranean during the second and first centuries BC were regarded by the Greeks as successors to the Macedonian kings, who were in their turn successors to Alexander the Great (d. 323 BC). The inspiration of Alexander is apparent in the portraits of Pompey, the most powerful Roman of his day, and for a time the effective ruler of the eastern Mediterranean. Much more than a military commander, Pompey appointed kings and created new Roman provinces. Like Alexander, he bore the name 'Magnus' (the Great), and imitated Alexander's leonine hairstyle and upturned gaze, a feature of Hellenistic royal portraits that implied an almost divine status. More commonly powerful Romans had themselves portrayed with their bodies idealised in the

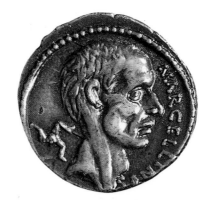
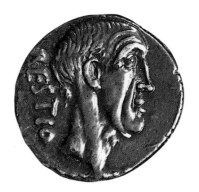

22 (*a*) Marcus Claudius Marcellus, consul in 222 BC, portrayed on a coin of his descendant minted about 170 years after Marcellus held office (*top left*). (*b*) Gaius Antius Restio, tribune of the Roman people in 71 BC, and portrayed on a coin minted by his descendant 24 years later (*top right*). (*c*) Unknown man: chalcedony intaglio in the traditional Republican style, made in the 1st century BC (*bottom left*).

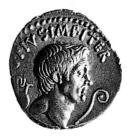

23 Pompey the Great, portrayed on a coin minted by his son Sextus Pompey in 38 BC.

Inside back cover

22a

22b

22c

24

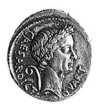
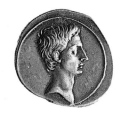
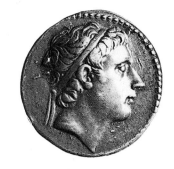
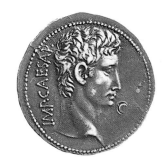

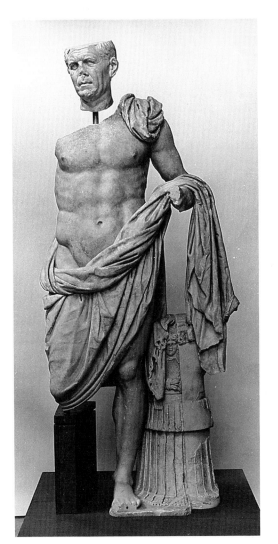

Greek manner and their heads idealised in the Roman tradition – indeed, even Pompey never quite lost his homely Roman countenance. The result was an aesthetic catastrophe, but the harshly jarring styles accurately conveyed the confusion of cultures in the early first century BC, a time when many well-to-do Romans completed their education in Athens, but when the moral values expressed in traditional Roman portraits were still considered an essential element in the representation of individuals.

Julius Caesar favoured a traditional style of portrait, but used his image in a regal manner that traditionalists found offensive. Caesar was the first Roman to allow his own portrait to appear on coins minted at Rome and elsewhere in his lifetime; his statue was carried on a litter, and set next to statues of the gods.

Portraits in the Empire

After Caesar's assassination in 44 BC his heir Octavian radically changed the style of portraits of Roman rulers. Following an interval of mourning for Caesar, Octavian adopted an image loosely based on that of earlier Hellenistic kings. But in the years after his victory at Actium (31 BC) it became clear that this form of portrait, bearing associations of foreign kingship, was ill suited to Octavian's self-proclaimed role as the restorer of the Roman Republic. The traditional Roman Republican

25 (*From left to right: a*) Julius Caesar, portrayed on a coin minted at Rome in 44 BC, the year of his assassination. Caesar was the first Roman to have himself portrayed on coins during his lifetime.
(*b*) Octavian, later Augustus, heir to Julius Caesar, portrayed on a coin minted in 36–31 BC.
(*c*) Antiochus III, King of Syria (223–187 BC), is thought to have been the model for the portraits of Octavian made at this period. (*d*) The new classicising image of Augustus appears on coinage as early as 27 BC.

24 (*Left*) Statue of a Roman general, portrayed in heroic semi-nudity. The head is in the traditional Republican style, but the body is idealised in the Greek manner. The general's cuirass appears as a support beside his left leg. Made about 70–50 BC. Found at Tivoli, near Rome.

26 (*Right*) Gaius Caesar, one of the grandsons of Augustus, and his favourite potential successor. (*Far right*) Tiberius Caesar, Augustus' stepson, at the time of his adoption as successor after Gaius' death in AD 4.

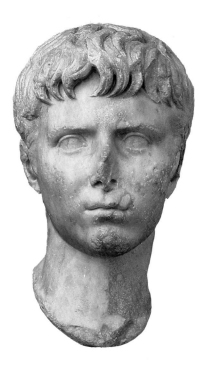

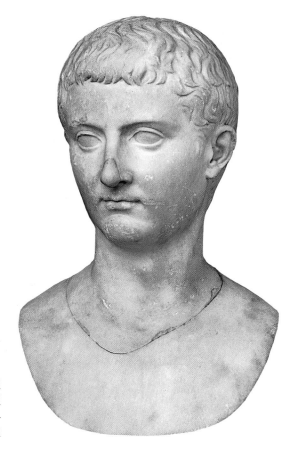

portrait was also problematic, since it had been so abused by Caesar. A more neutral image, fitting Octavian's presentation of himself as *princeps* ('first citizen') of the restored Republic, was required.

Although he deliberately affected a republican stance, in 27 BC Octavian effectively became emperor of Rome, taking the name Augustus. The first emperor's new image may be closely associated with the establishment of the new constitution, for it first appears on 25d coins minted in the eastern city of Pergamum in 27–26 BC. The new portrait was a bland adaptation of a Classical Greek figure, the spear-carrier created by the sculptor Polyclitus (p.18), which was thought to embody the ideal qualities of the human body and spirit. Though evidently representing the same individual, the head was much calmer than that of the agitated portrait of the previous decade. The emperor looked purposeful and

reassuring. The image did not change until the emperor's death at the age of 76 in AD 14.

Augustus' portrait was disseminated on coins and in sculptures throughout the Empire. The succession was complicated, and the various candidates were all portrayed in similar fashion, to suggest family likeness and political stability. It is thus quite difficult to 26 distinguish the various princes of the family of Augustus. The style survived, with modifications, until the end of the dynasty in AD 68, and it was deliberately revived in late antiquity by Constantine I (AD 307–37), the first emperor to embrace Christianity.

What happened in the early Empire to the traditional Roman portrait? It was still used

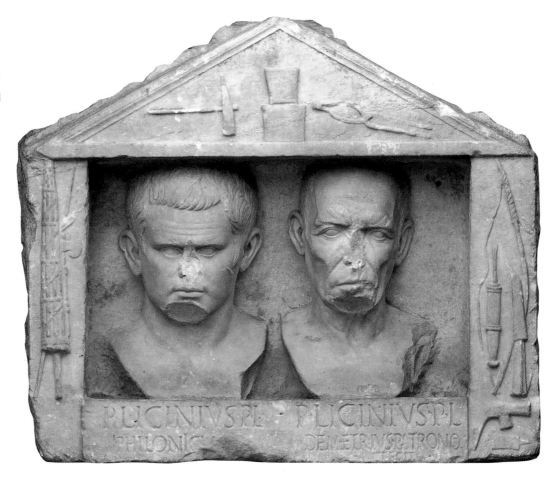

for images of private citizens, though some very important officials and foreign clients of Augustus based their images upon that of the emperor. The austere Republican image, formerly restricted by law to the nobility and to the families of serving magistrates, had by now become an expression of Roman identity. As such it was eagerly taken up by newly enfranchised members of Roman society. Under Augustus legislation was passed to allow freed slaves to marry and their children to become Roman citizens. Of alien origin, such people wanted to be portrayed as 'more Roman than the Romans'. They were commonly shown as half-figures carved in relief within a frame. 27 The marble block was then set into the wall of the family tomb, so the occupants appeared to be gazing at passers-by as if from a window. Hundreds of freedmen-reliefs have survived, mostly from Rome but also from elsewhere in Italy. It has been estimated that some 85 per cent of these are of Augustan date. Later, when freedmen had been assimilated into Roman society, there was no longer any need to proclaim Roman identity in this way.

The traditional style of Roman portrait was revived at the court of the emperor Vespasian 28 (AD 69–79), a man of modest Italian origin

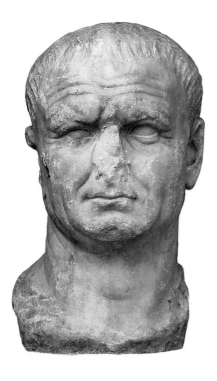

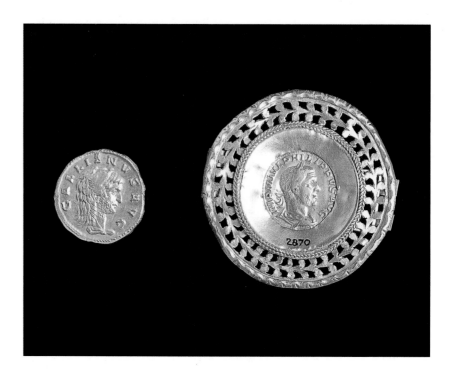

28 (*Above left*) Head from a statue of the emperor Vespasian (AD 69–79). From Carthage.

29 (*Above right*) Gold coin of the emperor Gallienus, minted at Rome in AD 262–3, to celebrate his tenth year as emperor (*left*), with (*right*) a coin mounted in a gold disc: portrait of the emperor Philip (AD 244–9).

who rose to power through command of an army following a year of civil war. The style passed to the provinces; by the late first century AD a Roman political career (*cursus honorum*) was the goal of men of provincial origin, and the Roman Empire offered many opportunities for personal advancement to wealthy provincials.

A similarly austere portrait style reappeared in the mid-third century AD during a period of prolonged crisis in the administration of the Roman Empire. From AD 235 to 285 the Empire was ruled by a succession of men, mostly of undistinguished provincial background, who had risen to power through the control of armies. These men appeared with shaven heads and grim, worried expressions. As is always the case with Roman portraiture, such images captured the subject's social class and preoccupations.

It is instructive to contrast the portrayal of

these emperors with that of the longest survivor of this period, the emperor Gallienus (AD 253–68). Of aristocratic family, Gallienus was highly educated, and his portrait exudes cultured refinement. His reign is often described as a period of revival of interest in Classical themes and modes of expression, but the profound change in the social composition of the court did not outlast the emperor.

The art of Gallienus' reign recalled happier days under the emperors of the second century AD. The imperial image had undergone a drastic change at the accession of Hadrian (AD 117–38). From this period until the reign of Constantine the emperor and his mature male subjects were almost invariably bearded. The wearing of beards had long been out of fashion at Rome: as we have seen, the contenders for power at the death of the Republic imitated the clean-shaven kings of the Hellenistic world. Nor were beards a feature of

30 (a) Octavian, bearded in mourning for the murdered Caesar. Coin minted in Gaul in 39 BC (*top*). (b) Gold coin issued in 193 BC by the Roman general Flamininus to commemorate his liberation of Greece from Macedonian rule (*middle*). (c) Bearded portrait of the emperor Nero on a coin issued after his declaration of the freedom of Greece in AD 65–6 (*bottom*).

traditional Republican portraits, though it is said that in the early Republic the Romans wore beards and long hair. The first barbers at Rome, of Sicilian origin, were said to have arrived in the city in 300 BC, after which date the Romans were clean-shaven. The date coincides with the institution at Alexandria of the cult of Alexander the Great, whose clean-shaven features were copied by many of his successors. It is likely that the Romans followed Alexandrian fashion in this respect, but surviving portraits of later date suggest that they retained their own conventions of representing character in facial features. The Romans of the later Republic and early Empire shaved off their beards at the age of twenty-four, and formally dedicated the shaven hair to the Lares, gods of the household, in a ceremony marking the transition to mature adulthood and public life. However, mature men did wear beards in mourning, and the very earliest portraits of Octavian show him bearded in grief for the death of Julius Caesar.

30a

Beards had been the norm in Classical Greece for portraits of politicians and philosophers. In the wake of Macedonian rule of their cities many intellectuals of late Classical and Hellenistic Greece retained their beards, deliberately intending a contrast with their rulers. Beards also signified an association with traditional Greek culture, and as such they were worn by some later Macedonian kings and philhellene Romans. The Roman general Flamininus, who proclaimed the freedom of Greece from Macedonian rule in the stadium at Isthmia (near Corinth) in 196 BC, was portrayed bearded. Two centuries later Flamininus was emulated by the Roman emperor Nero (AD 54–68), who had a passion for Greek culture and who, in AD 67, exempted all Greek cities, by then incorporated within the Roman province of Achaia, from taxation and Roman interference in local administration. Nero also made his proclamation in the

19

30b

30c

stadium at Isthmia in a deliberate evocation of Flamininus, and adopted a bearded portrait at about this time.

There are some bearded private portraits surviving from this period. The emperor's antics on stage embarrassed the Roman Senate, but the opening of membership of that august body to Greeks led to an irreversible improvement in the standing of Greeks within the Roman Empire. By the turn of the century Greek men of culture held prominent local office. Even the city of Athens, not yet recovered from the devastations of the first century BC, had begun to flourish. Hadrian served as *archon* (chief magistrate) of the city four years before he became emperor. Though his detractors claimed that Hadrian's beard was grown to hide blemishes on his skin, it more likely reflects the emperor's profound commitment to Greek culture. His interest was advertised personally, in his appearance and manner, and publicly, in his favourable treatment of the cities of the Greek heartlands and in his decoration of public buildings and imperial residences at Rome. Hadrian's energy, mobility and his tendency to intervene in provincial and private affairs led to far-reaching changes, both in the personal appearance of his subjects and in wider aspects of public and private life. From his reign onwards the Romans reversed their view of beards as symbols of immature adulthood and apparently embraced the ethical values of late Classical and Hellenistic Greece. The fashion for beards even survived emperors with no interest in Greek culture, such as Antoninus Pius (AD 138–61), who as emperor ventured no further than Naples, and continued in the succeeding century, despite a series of military *coups* by men of Balkan origins with no cultural pretensions.

Recent research has confirmed the long-assumed view that court fashions were rapidly adopted by the provincial aristocracy. The

Back cover

9

31

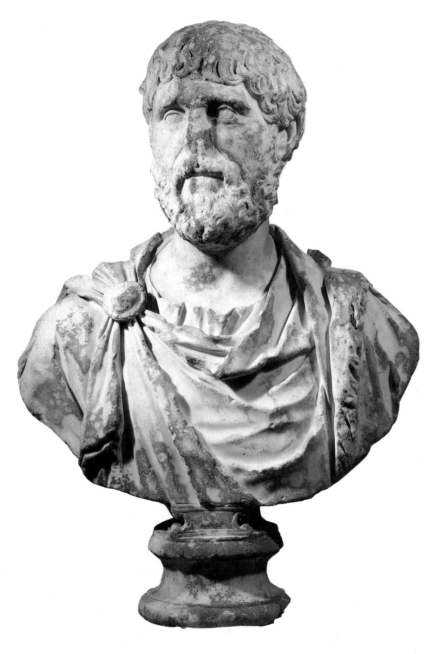

31 Bust of a man in tunic and fringed cloak. Found in a Roman villa at Lullingstone, Kent. The nose is mutilated; the bust was apparently deliberately buried in late antiquity with a companion piece of slightly later date. This portrait, probably made in Italy, exemplifies the intellectual refinement of the middle of the 2nd century AD.

copying of rulers' portraits by private individuals may seem particularly characteristic of the Roman Empire, but it was already apparent in the Hellenistic kingdom of Ptolemaic Egypt and its dependent territories, notably Cyprus. Most likely the introduction of a cult of worship of the ruler was responsible for this development, which is reflected in small objects as in large statues.

No evidence survives for the means by which the portraits of the emperor and his court were sent around the Empire. It seems clear from the surviving images that emperors took interest in and approved the form of their portraits, particularly those that would be seen by many of their subjects on coins and statues set up in public places. There are some indications that inappropriate dedications were not approved: in Rome alone Augustus had eighty silver portraits of himself destroyed, declaring that such images were unsuited to portraiture of mortals. However, the act of dedicating a portrait and describing its subject on an accompanying inscription was not necessarily initiated by the emperor. In the eastern provinces, where there were well-established traditions of kingship, many surviving dedications were made up by local communities who likened the reigning emperor to a god.

In antiquity portraits served as surrogates for their subjects. Petitions were fastened to a statue of Julius Caesar set up in the Roman Forum, and appeals for justice were made to statues of emperors in later antiquity. As imperial portraits attracted faith, so images of emperors who had betrayed their subjects' trust were treated with contempt. The phrase *damnatio memoriae* (formal condemnation of an emperor following his death) refers not to the repealing of the acts of an unpopular emperor but to the destruction of his images and the elimination of his name from inscriptions. Such destruction could be vicious: the

staid senator, the Younger Pliny, was vehement in his description of the fate that befell the portraits of the emperor Domitian on his downfall in AD 96:

It was our delight to dash those proud faces to the ground, to smite them with the sword and savage them with the axe, as if blood and agony could follow from every blow. Our transports of joy, so long deferred, were unrestrained; all sought a form of vengeance in beholding those mutilated bodies, limbs hacked in pieces, and finally that baleful, fearsome visage cast into the fire, to be melted down ... (Pan. 52)

Damage to the imperial image could reflect contemporary forms of punishment. Thus the over-life-sized bronze head of Augustus found at Meroë (Sudan) was detached from its body by Meroitic tribesmen raiding Roman camps in upper Egypt, carried to the site of a temple of victory, and deliberately buried beneath the steps leading into the temple. Anyone entering the shrine committed the insult of literally stepping on the head of the Roman emperor. Inside the shrine wall-paintings showed the young king of Meroë with his feet resting on lines of bound prisoners (one of them possibly a Roman legionary) who were being subjected to the same indignity. In the later Empire Christians took vengeance upon the representatives of pagan authority by mutilating a bust of Germanicus Caesar, in his day one of the most popular members of Augustus' family: the nose was sliced off and a cross was cut into the forehead.

The reworking of heads of unpopular emperors was not uncommon. Even 'good' emperors could be reused for portraits of their successors by provincial craftsmen short of material. Less radically, the fashion for making heads, arms and feet from separate blocks of stone allowed the insertion of new portrait heads in old torsos, a practice condemned by some Roman and Greek writers.

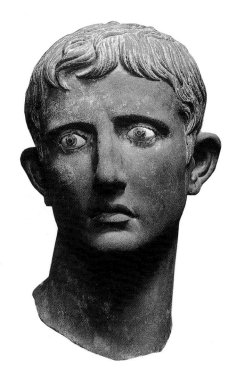

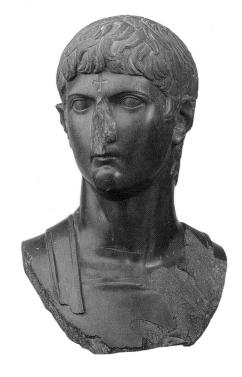

32 (Right) Bronze head decapitated from a statue of Augustus in 25–24 BC. Found in a temple of victory at Meroe, Sudan.

33 (Far right) Bust of Germanicus Caesar. Made about AD 20 of green basanite. The bust was mutilated in late antiquity, probably by Christians who carved a cross in the forehead. Probably from Egypt.

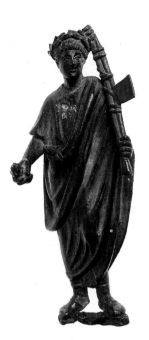

34 Bronze statue of a *lictor* (magistrate's attendant). The youth carries the symbols of magisterial office. He is dressed in a toga with *sinus* and *umbo*. Late 1st century BC.

Fashion in dress, hair and jewellery

In the Roman Empire, as now, dress could serve as an eloquent expression of social rank, ethnic origin, political allegiance or religious belief, and especially as a sign of cultural aspiration. Though Hellenistic Greek kings were frequently portrayed naked, a device suggesting superhuman status, Roman Republican notables were more modestly portrayed in military dress or wearing a traditional Roman garment – the toga, a large woollen cloak with curved hem. Beneath lay a simple tunic. By the first century BC a straight-edged Greek cloak, often made of fine cloth, had become fashionable for men and women. The *pallium* (Greek, *himation*) was tightly draped to give a swaddled appearance. Augustus revived the toga as a form of national dress, and insisted that Roman men wore the toga in the Forum and when attending races at the circus. A new way of wearing the toga was developed, hitching the voluminous garment off the ground with a long fold (the *sinus*) below the right arm. The edge of the toga was drawn up to form a loop of cloth (*umbo*) by the waist. As the toga increased in social importance it also gained in size, though it clearly remained a difficult garment to wear. The complex folds introduced by Augustus were simplified in succeeding centuries, and eventually the toga was evidently only worn on formal occasions. An amusing vignette of the complexities of formal Roman dress is given by the late antique writer Macrobius, who describes the difficulties of a dandy, Hortensius:

To go out well-dressed, he checked his appearance in the mirror, and so draped the toga on his body that a graceful knot gathered the folds, arranging them not randomly but with care, so that the *sinus* was composed to flow down the side, defining its outline. On one occasion when he had arranged it with elaborate care, he charged a colleague who brushed against him in a narrow passage, destroying the structure of his toga. He thought it a crime that folds should be moved from their place on his shoulder. (*Satires* 3, 13, 4)

Even in late antiquity the wearing of the toga remained a privilege indicative of age, sex and social rank. Boys wore the *toga praetexta*, with a purple band around the hem. On attaining manhood this was formally exchanged for the *toga virilis* or *pura*, a white garment. Magistrates, like boys, wore the

35 (*Right*) The ceding of military victory to Augustus by Tiberius following a successful Alpine campaign in 16/15 BC. (*Right*) On a commemorative scabbard made for a senior officer, Augustus appears in the pose of Jupiter, and receives a statuette of Victory from Tiberius. Mars Ultor and Victory attend the ceremony to give divine approval to the emperor's formal acceptance of victory. (*Left*) On a coin with wide circulation, Augustus is modestly dressed in a toga and receives symbols of victory from Tiberius and his colleague Drusus.

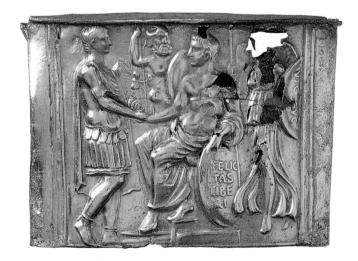

praetexta, and *flamines* (priests of the imperial cult) a scarlet toga with a purple border. Perhaps in personal support of his campaign to restore the toga as a symbol of Roman male identity, Augustus usually appeared in his portraits dressed in a toga. Often the toga was drawn over his head to make a veil, worn at the performance of religious rites. However, in portraits made as gifts from loyal individuals, notably cameos and commemorative weapons, Augustus allowed the Republican mask to slip, and was portrayed in god-like pose and dress. In contrast only one surviving statue of Hadrian shows him dressed in a toga. By this period it was no longer necessary for the emperor to stress Roman identity.

Women were often portrayed in Greek dress, usually the *chiton*, a voluminous tunic, made of lightweight cloth such as linen, buttoned down the sleeves and belted above the waist. Less common was the Doric *peplos*, a sleeveless tunic with overfold gathered in at the waist, the whole pinned or buttoned at the shoulders. Greek dress became more common for men after Hadrian's enthusiastic adoption of Greek fashions, and is often seen in early Christian art.

Though the Hadrianic fashion for Greek dress and hairstyles proved pervasive, other imperial initiatives did not. An interesting example is the *stola*, a traditional female garment deliberately revived by Augustus as an expression of his policy of moral restraint upon members of the aristocracy, not least his own family. Some poetic complaints survive on the concealing nature of this dress, designed to cover the tunic but to be worn beneath a cloak. But women clearly found ways of turning a restrictive garment into an alluring fashion: the surviving representations of the *stola* show it as a revealing slip, cut low between the breasts and often suspended from the slimmest of decorative straps. Most surviving portraits of *feminae stolatae* (women

Front cover 35

Back cover

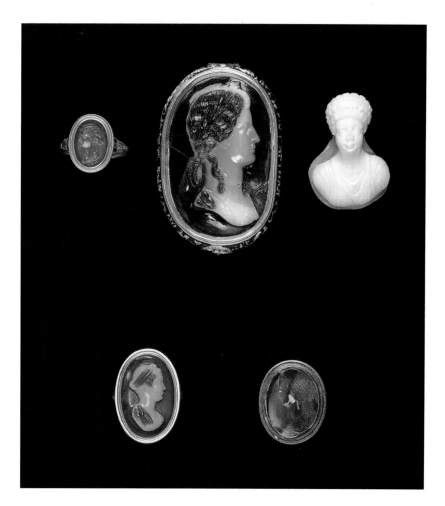

legally privileged to wear the *stola*) of the Augustan dynasty are cameos or fine marble busts. The majority represent relatives of the emperor Gaius (called 'Caligula': AD 37–41), princesses who received exceptional privileges from the emperor. There are a few later portraits of women wearing the *stola*; some, from provincial Italy and elsewhere, are of private citizens. None is later than about AD 100, after which the fashion seems to have been supplanted by the taste for a Greek appearance. However, the title *matrona* or *femina stolata* appears in later funerary inscrip-

36 Five gems illustrate developments in women's hairstyles and fashions in dress from the early Empire to the later 2nd century AD. *Top row, left to right*: (*a*) early Augustan, 30–10 BC; (*b*) the younger Agrippina wearing a *stola*, about AD 38; (*c*) a woman wearing the *stola*, about AD 90; *bottom row, left*: (*d*) Hadrianic, about AD 120–40; *right*: (*e*) mid-Antonine, AD 160–70.

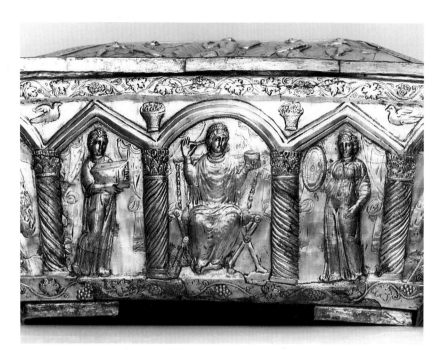

37 The front of Projecta's casket: the seated Projecta receives two attendants, who bring a casket and a mirror while Projecta perfumes her hair. The composition of the three figures is reminiscent of Greek vases of the later 5th century BC. Made in Rome in the later 4th century AD.

Europe. Wigs, hair-pieces or frames were used to give added height. Young women of this period were often portrayed with a coquettish appearance. As freedmen and freedwomen rose to previously unimaginable positions of political power and wealth, some portraits Inside front c were made which likened their subjects to deities. Such images, it may be surmised, were not well received by the nobility, who continued to commission portraits of conventionally austere appearance.

The reaction to *fin-de-siècle* excess was a retreat to harsh severity. In the early second century women continued to be portrayed with their hair piled in tiers above the brow, but the tightly restrained locks were deeply unflattering in comparison with the coiffures of Flavian portraits. Facial expressions became suitably harsh and drapery appropriately modest. In the Hadrianic period the tiers of 36d locks disappeared, and hair was simply drawn 39 into a plaited bun set high on the crown of the head. This development, like the revival of beards, was inspired by the contemporary passion for Greek culture. By the end of the century the bun had slid to the back of the 36e head, where it appeared as a flatly coiled plait. The hair was now centrally parted, and crimped on either side of the face. This hairstyle proved pervasive, lasting with minor variations into late antiquity. On a casket made in Rome in the later fourth century AD commemorating her marriage, a woman named Projecta appears with the flattened 37 plaits coiled onto the crown of her head. She is modestly draped but wears jewellery, and in one vignette she applies perfume to her hair with a pin dipped in a flask. ·

Although jewellery is known from burials 40 throughout the Empire, the best evidence for how it was worn comes from Egypt and the Levant in portraits painted on wood and 39 carved in stone. Funerary reliefs from Palmyra 38 (Syria) are particularly rich in the representa-

tions, with the implication, derived from the earlier Empire, of high social rank.

As with dress, hairstyles also reflected not only the social status of the subject but, to some extent, the moral climate of a reign. Women's hairstyles were copied so rapidly that, for the modern historian, they provide a good indication of the date of a portrait. In the later Republic and under Augustus hair was 36a well restrained, tightly drawn back from the face and elaborately plaited over the crown of the head, the bulk wound into a bun at the nape of the neck. After the death of Augustus the style became less restrictive; pincurls appeared around the brow, and locks of hair 36b escaped the bun, which grew longer and tail-shaped. In the later first century overwhelming emphasis was placed on the hair framing 36c the face. The pincurls became larger and were arranged in tiers. Women's hairstyles under the Flavian emperors (AD 69–96) became as fantastic as those of eighteenth-century

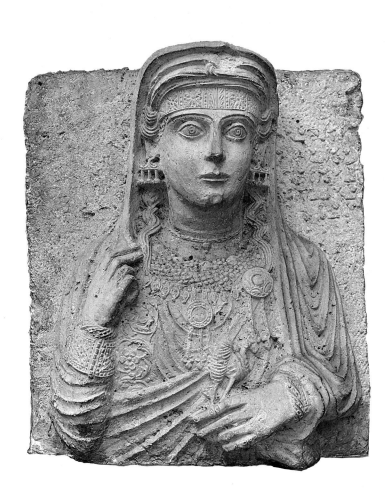

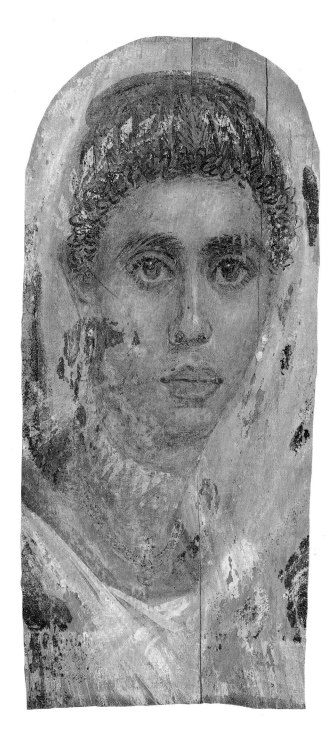

38 (*Above*) Limestone bust of Tamma, daughter of Shamsigeram. From Palmyra, Syria. 2nd century AD. The subject is richly bedecked with jewellery.

39 (*Right*) Portrait of a woman wearing a gold wreath, hooped earrings set with pearls, and two gold necklaces. AD 130–150. Perhaps from Saqqara, Egypt.

40 Jewellery from a woman's tomb at Miletopolis, on the southern shore of the Sea of Marmara. The jewels include a cameo portrait of a woman, made about AD 200.

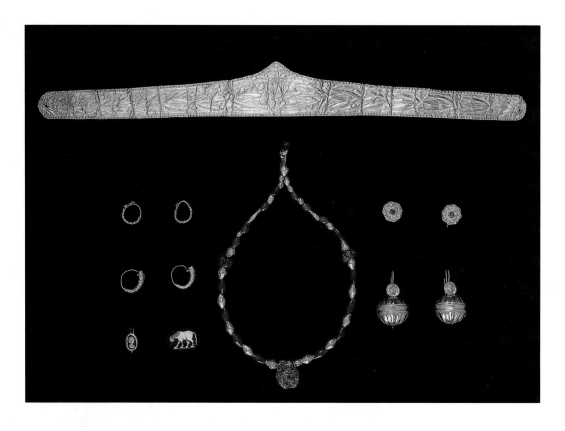

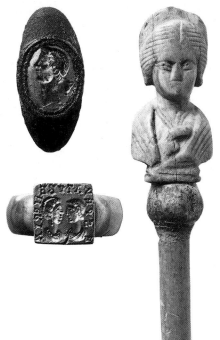

41 (*Right*) Jewellery used for portraiture: (*a*) Caesar appears on a gilded emblem set in an iron ring, worn by a member of the Caesarian faction in the civil wars following the Dictator's murder in 44 BC (*above left*). (*b*) Portrait of a couple on a commemorative wedding ring. Made about AD 200 (*below left*). (*c*) Portrait of a woman on a bone pin. Early 3rd century AD (*right*).

tion of jewels. Some stone heads, notably female portraits from Cyrene, which remained culturally close to Egypt after the incorporation of both areas within the Roman Empire, have cuttings for the insertion of metal earrings and hairpins. Much jewellery, especially gemstones and hairpins, was itself used as a vehicle for portraiture. Wearing the portrait of a military or political leader upon a ring or on a coin mounted as a jewel was an obvious sign of allegiance; other portraits of unknown individuals were presumably private commemorations.

41a

41b.

Portraits of children

An interesting class of portraits consists of depictions of Roman children. Most surviving examples are funerary, often commissioned quickly in response to unexpected death from disease, by no means uncommon in antiquity. Sometimes portraits of mature adults were used for children and adolescents, not necessarily of the same sex as the intended subject. Many portraits of infant boys appear to have a hairstyle resembling that of the emperor Trajan (AD 98–117). However, it is misleading to date the portraits on that basis, as they are a naturalistic rendering of the appearance of boys after the loss of infant curls at the age of two or three. Some portraits of young children copy imperial features in, for example, the shape of the ears or in their hairstyles.

No child is known to have appeared on a public monument until the age of Augustus, when the *Ara Pacis Augustae* (Altar of Augustan Peace) presented members of the imperial family and others prominent in public life in their role as heads of families, the children naturalistically shown tugging on togas and hushed by nurses. For the first time in classical antiquity the nuclear family had assumed a central role in the politics of state. Some later public monuments also included portraits of children, and by the second century AD the notion of including portraits of children in public monuments had spread to some highly influential provincial families. The portraits were arranged to form a three-dimensional family tree, and to suggest links with the imperial family in Rome. Beneath the wealth of statuary and architectural ornament, such monuments usually had a practical purpose.

One surviving example is the fountain built by the Athenian millionaire Herodes Atticus in the sanctuary at Olympia (Greece); another is the handsome gymnasium given by Publius Vedius Antoninus to the city of Ephesus, the provincial capital of Asia. The combination of utilitarian function, personal advertisement through statues and inscriptions, and florid architectural ornament is typical of imperial buildings in the Mediterranean provinces in their heyday from the late first century to the early third century AD.

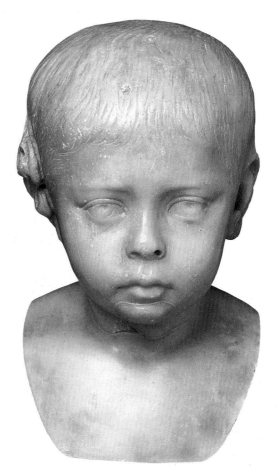

42 Bust of a small boy, an initiate in the cult of the Egyptian god Serapis. 2nd century AD.

3 From Bath to Baalbek: public art in the Roman Empire

Many people, if pressed for an opinion on the artistic achievement of Rome, think of architecture grand in scale, but utilitarian in nature. Well-paved roads, aqueducts, baths, public lavatories (to modern eyes surprisingly convivial!), central heating and decent plumbing comprise the Roman achievement. The Romans' apparent obsession with personal comfort makes them appear closer to modern sensibilities than the austere Greeks. But a less comfortable feeling is aroused by some Roman public buildings: the Colosseum at Rome, a mightily impressive structure, raises unhappy thoughts of the apparently insatiable Roman taste for slaughter of beasts and people. Triumphal arches, too, are impressive and some are elegant, but covered with unsubtle allusions to Roman military might. Modern discomfort has been increased by the adoption of Roman symbols and designs by twentieth-century totalitarian regimes. This feeling is nowhere more apparent than in Rome itself, where the monumental centre of the ancient city was brought to its present form during the Fascist period. The Via dei Fori Imperiali, Mussolini's triumphal route linking the Colosseum to the Piazza Venezia, cut right through the ancient imperial centre. The construction of this highway entailed the destruction of medieval quarters of the city, and the enforced resettlement of modern inhabitants in peripheral slums. It also effectively made the ancient imperial fora showplaces for contemporary imperialist ambition. In this there was an element of ironic justice. The nearby Forum Romanum was until the late Republic an open space reserved for political and religious activity. Julius Caesar built his own Forum nearby. This, in common with most later imperial fora, was fringed by colonnades and dominated by a temple. The intrusive architectural form and propagandistic sculptural decoration of the imperial fora must have reminded the Romans of the loss of their political freedom.

43

In antiquity Rome was exceptional, a personal showcase for the emperor's power and munificence. Already developed by the triumphant generals of the later Republic, from the later reign of Augustus no-one but the emperor was allowed to build public amenities in it. Provincial cities might also attract imperial attention and largesse – Hadrian (AD 117–38) is particularly noted for his generosity in this respect – but by and large they depended on the goodwill of local notables to emulate the emperor. The provincial élite took their civic duties seriously, especially in those areas, such as Asia Minor, where cities were traditionally furnished with a complete range of amenities.

Those who decry the piecemeal private spoliation of post-war London may admire the Roman obsession with the appearance of their cities. Like many other aspects of Roman artistic and technical development, interest in town-planning was much influenced by contact with the Greek east. Theories of town-planning and land distribution had been developed in the Greek cities in the Classical period. These rational ideas, along with Etruscan traditions of defining urban boundaries, may well have influenced the planning of new Roman colonies and forts during the Republic. But when it came to furnishing the great cities of the Empire with magnificent public buildings the Romans were more attracted to the grand designs of the Hellenistic kings in the eastern Mediterranean.

At Rome a plan worthy of the capital of empire was advanced by Augustus, who boasted that he had found a city of brick, and changed it to one of marble. Nonetheless, Augustus showed more political sensitivity than his modern imitators, limiting the shape of his Forum to fit the contours of the Oppian Hill, so (he claimed) no inhabitants were displaced. The Forum was not completed until 2 BC, by which time opponents of his regime had either been eliminated or become reconciled to the

virtues of political and economic stability. The surviving vestiges of Augustus' Forum offer only a hint of the original form, which many surely found oppressive. The spoils of war adorned the entrance, through which could be admired an enormous bronze statue of the emperor riding in a four-horse chariot. The colonnades lining the sides of the Forum were furnished with niches, in which stood statues of heroes from the early history of Rome: Horatius, Fabius Maximus, and so on. Beneath each figure was inscribed an *elogium*, elegantly encapsulating the hero's achievements. It is thought that Augustus himself composed these verses. The heroes were so arranged as to suggest a natural progression from the legendary founder of Rome to the first emperor, who in reality owed his position to the successful waging of a bitter and protracted civil war, followed by a ruthless purge of surviving opponents. The colonnades opened into curved bays, in one of which was set a statue of Aeneas, with the kings of Alba Longa and members of Augustus' family. Opposite Aeneas stood Romulus, legendary founder of the city of Rome, with more great men of the Republic. Again, the placement of the figures was suggestive of a closer relationship than could be claimed in reality. At the back of the Forum, dominating the space from a high podium, stood a temple dedicated to Augustus' patron deity, Mars Ultor (the avenger), the god of justifiable war. Within the cella were statues of Mars Ultor, Venus, the patron goddess of Augustus' family, and Julius Caesar, Augustus' adoptive father. The entire Forum was lavishly decorated with expensive Greek and Asiatic marbles. Allusions to Classical culture appeared in the upper stories of the colonnades, which were decorated with copies of the caryatids from the Erechtheum on the Athenian Acropolis.

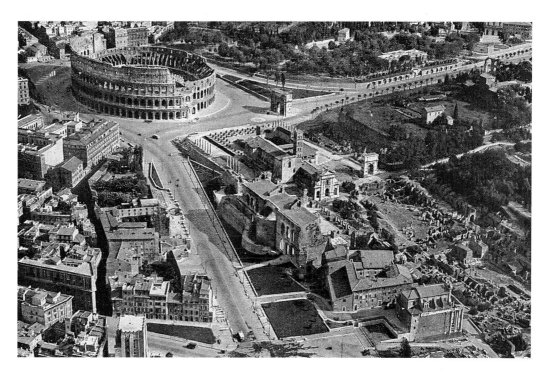

43 The Colosseum, the Arches of Constantine and Titus, and part of the Roman Forum and the Palatine Hill. In the foreground is the Via dei Fori Imperiali in the time of Mussolini (undated aerial photograph published in 1941).

44 Two heads from a series of statues of members of the Roman imperial family, found in the sanctuary of Athena Polias at Priene (western Asia Minor): (*left*) Julius Caesar; (*right*) Claudius. Made about AD 50.

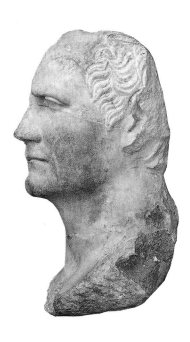
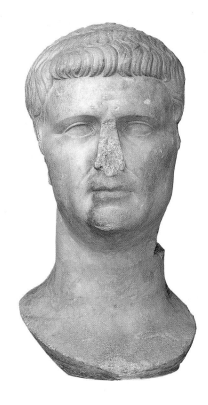

The Forum of Augustus is a striking example of the Roman tendency to set a monument in a precise historical context. While the Greeks, especially in the democratic cities, preferred to allude to historical events through myth, the Romans developed a direct record of the events and the characters they wished to commemorate. The decorative schemes of major Roman monuments were often very complex, as can be seen from this brief outline of the known areas of the Forum of Augustus. Here we see direct allusions to military victories, portraits of historical and legendary figures, representations of the intervention of the gods in human affairs, and reference to Rome's interest in protecting the heritage of Classical Greece. Often Roman art is described as eclectic, and it is indeed true that the designs of complex monuments were frequently drawn from many sources. Our difficulty in interpreting Roman ruins is that the coherent scheme rarely survives; we are left with only fragments, from which it is impossible to reconstruct the nuances of a scheme. Most large-scale metal statues, many of gilded bronze, are long since lost to the melting-pot. The famous equestrian statue of the emperor Marcus Aurelius (AD 161–80), which until recently adorned the piazza of the Capitoline Hill in Rome, only survived because it was thought that the image represented Constantine I, the first emperor officially to adopt Christianity. Having escaped the foundry, the intellectual pagan emperor has fallen victim to the modern threat of carbon dioxide emissions from passing cars, and must now be admired within the confines of a museum.

The imperial cult in the provinces

Augustus and his successors evidently felt no scruples about receiving extravagant, even divine, honours in their lifetimes, at least in the Greek cities, which were far from Rome and accustomed to conspicuous flattery of alien rulers. Those emperors whose memory was not condemned were deified, a tradition established after the murder of Julius Caesar. In this spirit an entire cycle of statues of the imperial family, from Julius Caesar to the emperor Claudius, was set up 'by the people' in the Classical sanctuary of Athena Polias at Priene in Asia Minor, and in the surviving texts from Priene the 'first citizen of Rome', as Augustus liked to style himself, was described as a god. Such initiatives were by no means uncommon, and were gradually institutionalised. A century later the traveller Pausanias, himself a native of south-west Asia Minor, was to complain about the invasion of statues of the Roman imperial family in the ancient temple of the mother of the gods at Olympia in western Greece. Complaints were the luxury of a people conscious of barbarians desperate to belong to the Roman Empire. No complaints survive from the period of the early dedications, except in the form of riots in peripheral western provinces, where cities were unknown and the cult of the emperors was imposed by Rome. There were, too, groups who steadfastly refused to accept the imperial cult of which the most significant were separatist Jews.

Commemorative monuments

There is a long history of unease on the part of city councillors and other less privileged groups over extravagent urban development in classical antiquity. If we are to believe the Roman commentator Plutarch, Pericles himself got into some difficulties over the development of the Acropolis at Athens nearly half a millennium before his Roman imitator Augustus. Accused of misusing funds contributed by the allies of Athens for defence, Pericles replied that the allies could have no say in how the monies were spent once Athens had fulfilled her military obligations. Most urban development in classical antiquity was funded by the profits of empire, or by the personal wealth of tyrants and kings. Early Rome was first developed by the later kings, who patronised artists and architects as did the tyrants of Archaic Athens. The buildings of later Republican Rome were funded by the spoils of expansionist wars. In the provinces of the Roman Empire, wealthy individuals were expected to pay. The hope for *fama* – lasting glory – was a strong incentive for the building of public works by rich and powerful individuals throughout antiquity. In Roman law those who paid for public amenities were entitled to record their names in dedicatory inscriptions on the buildings.

Surviving Roman monumental inscriptions are often of high artistic quality. Letters were cut into the stone and then painted, gilded, or

45 Dedication in Latin to the god Apollo by [U]mbricius, son of Gaius, and [C]aburcus. From Falerii (Civita Castellana). Early 1st century BC.

46 (*Top*) The inscription on the base of the Column of Trajan, Rome. The text alludes to the amount of earth removed to build the column. The interior served as Trajan's burial chamber.

47 (*Below*) Dedicatory inscription of the King Edward VII building, north façade of the British Museum, Montague Place. Although written in English, the lettering and presentation of the text are inspired by Latin inscriptions of the Trajanic era.

inlaid in metal. The earliest Latin inscriptions are hard to distinguish from contemporary written documents in other Italic languages. By the third century BC intelligible Latin was written, and the letters were even embellished with serifs (decorative finishing strokes). These are also found on contemporary Greek inscriptions. Some attempt was made in later Republican inscriptions to contrast thick and thin strokes.

The finest monumental Latin inscriptions are dated between the time of Augustus and the end of the second century AD. The best inscriptions in Rome, such as that on the base of the Column of Trajan, were studied and drawn by Renaissance scholars and artists, and have thus influenced the style of modern lettering and printing. In the third century AD the art of calligraphy began to decline. However, it is important to distinguish regional styles, and imperial from private commissions.

48 (*Left*) Dedication by veterans of the 2nd legion to the emperor Septimius Severus. A fine example of Severan calligraphy, of which many examples are known from North Africa. From Nicopolis, Egypt. AD 198.

49 (*Below*) Dedication to the god Zeus Keraunos on behalf of the emperor Hadrian. A Palmyrene text appears below the Greek. From Et-Tayyibe, near Palmyra, Syria.

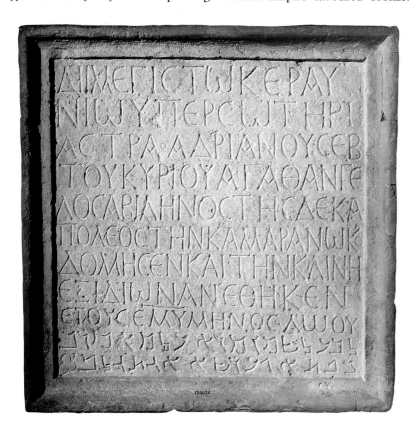

Variation in quality makes it difficult to date Latin inscriptions by the style of the lettering alone. There are many fine calligraphic inscriptions from early third-century sites in 48 Africa, an area of great imperial interest: at this period the emperor's attention was less focused upon Rome.

In the eastern Empire most monumental inscriptions and public dedications were in Greek, a language that flourished through the Roman Empire in the provinces bordering the Mediterranean from Greece round to Cyrenaica (eastern Libya). Some inscriptions were bilingual in Latin and Greek, or in Greek and a 49 local script such as Palmyrene. In the Greek world there were long-standing traditions of recording documents on stone, while the Latin-speaking western Empire favoured bronze.

The Greek documentary tradition persisted through the Roman Empire, but the large-scale records of public building so typical of the Latin west are not so common in the eastern provinces.

The donors of public buildings in the provinces were also apparently permitted to commission a display of statues. These were most commonly portraits of the donor and his family, set on bases inscribed with their names and achievements. The labelled images were 50 usually placed in niches cut into the interior or exterior walls of the building. Statues set into the exterior wall of a building were further enhanced by decorative architectural orders which projected from the wall. The columns acted as a frame to the niche, thereby increasing the impression of grandeur, and they also served the practical function of protecting the sculptures from the weather. The fashion for covering the exterior walls of Roman buildings with sculptures protected by architectural orders became widespread as the marble trade became systematically organised in the second century AD. The fashion was to influence the decoration of later monuments as geographically and chronologically diverse as Gandharan *stupas* and northern European cathedrals.

Following the example set by Augustus, portraits set in the walls of buildings could be suggestively arranged to complement dedications to the emperor and his family, and dedications to appropriate deities. The Muses, then, might appear in a library, and a river-god in a fountain. Portrayed next to a Muse, a donor might attract some cultural allure. Juxtaposition with an emperor suggested power and influence. Some donors spared no expense in commemorating themselves and their families. The portraits (some of touchingly poor quality) were sometimes dedicated by an aspiring relative – a son or son-in-law – or by the grateful local council.

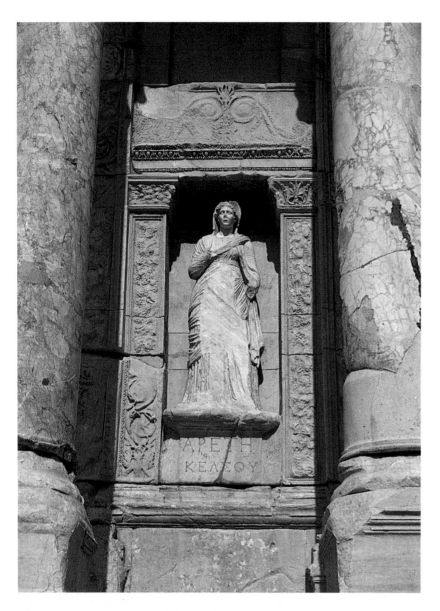

50 Statue personifying the virtue of Celsus, set in a niche protected by projecting columns in the façade of the library given by Celsus to the city of Ephesus. On his death in AD 134 Celsus was buried in the library.

The burdens and blessings of urban development

As Pericles had found, grandiose schemes for civic adornment were not always popular. Many Romans preferred cash hand-outs, doles of corn or oil, or a fine gladiatorial display to the provision of a fountain or library decked with gaudy statues reminding the illiterate of their lowly place. Sometimes the emperor had to intercede in local affairs to resolve conflicts between rich and poor over the provision of urban amenities. A series of letters survives from the city of Ephesus, correspondence between the council and the then emperor, Antoninus Pius (who never visited the Greek provinces as emperor), regarding the efforts of a local worthy, Publius Vedius Antoninus. The council complained of unwarranted expenditure by Vedius Antoninus on the provision of new public buildings. The emperor reminded the council of the benefits to be derived from the rich. Later Pius was to chide the council for their slow response to Vedius' demands for a permit to build. The gymnasium of Vedius survives to this day. More correspondence survives concerning another dispute over the status of the cities of Ephesus and Smyrna. The latter city resented Ephesus' official status as the point of disembarkation for emperors and senior Roman officials visiting the province of Asia. Pius confirmed that Ephesus was to retain this privilege, but awarded other distinctions to Smyrna to lessen the blow.

The letters of the Younger Pliny, governor of the province of Bithynia on the southern shores of the Sea of Marmara (north-west Asia Minor), and the contemporary account of Dio of Prusa, also in Bithynia, reveal that some projects were ill-founded speculations. Pliny and Dio wrote in the reign of Trajan (AD 98– 117), a time when the wealthy cities of Asia Minor enjoyed a building boom. It seems that

the council of Ephesus (again!) to clean the great harbour. In many provinces huge efforts were required to repair the consequences of neglect following a protracted period of political, military and economic instability in the third century AD.

Such was the negative side of the balance sheet. The positive was considerable. Cities, recognisably Roman and supplied with a fine range of amenities, were built from Bath to Baalbek and beyond. Even the recalcitrant British were persuaded of the virtues of baths and fine togas (at least for ceremonial occasions). The wealthier citizens of other provinces eagerly adopted the Roman way of life. Never before (or since) had an imperial power proved so open to the advancement of its subject peoples.

Ways of promotion were twofold: civilian, in the form of services provided to Roman government, and military. In both spheres a shortage of qualified men necessitated the

the problems grew worse as the second century progressed. The aqueduct built for a city called Alexandria near Troy by the Athenian millionaire Herodes Atticus came in at over twice the estimated cost. An unfavourable report was made to the provincial governor, who, alarmed, informed the emperor Hadrian. The emperor refused to meet the extra costs from public money, but Herodes' father loftily resolved the difficulty by supplying cash, as it were, from his own pocket.

Rivalry between the rich in neighbouring cities needed to be turned from a risk to political stability to a benefit for the common good by diverting energies into the provision of public buildings under imperial control. With the increase in the provision of 'high-technology' amenities such as aqueducts and large harbours, there also arose a persistent problem of maintenance. Surviving official letters reveal the emperor Antoninus Pius nagging

51 (*Left*) Portrait head of Herodes Atticus, the Athenian millionaire, Roman consul, philosopher and tutor to the future emperors Marcus Aurelius and Lucius Verus. Made about AD 180. Winchester City Museum.

52 (*Below*) Part of a bronze diploma recording the grant of Roman citizenship and the right of legitimate marriage to Marcus Papirius of Arsinoe, Egypt, to his wife Tapaia, and to his son Carpinius, following the discharge of Papirius after 25 years' service in the Roman navy. Dated 8 September AD 79.

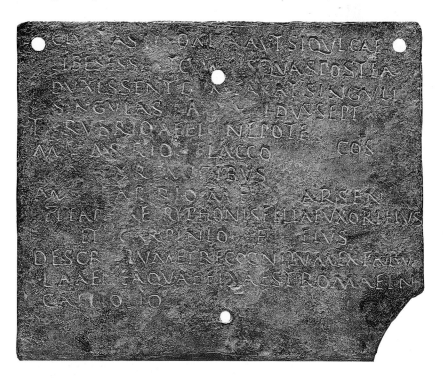

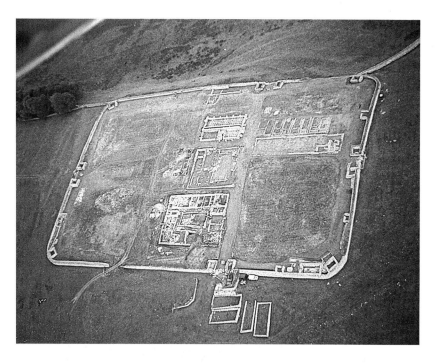

53 (*Above*) Aerial view of the Roman fort at Housesteads, Hadrian's Wall.

gradual recruitment of provincials. Throughout the Empire the army remained a formidable presence, shifting from frontier to frontier with changing military priorities. Forts were built with highly refined precision, most so standardised that the size of their garrison and the appointments provided may even now be accurately estimated from an aerial photograph prior to excavation. The design of Roman forts had been developed by the second century BC, when the Greek historian Polybius wrote an account of their features. Another account was written by Vegetius five hundred years later; the significant differences may be explained by changes in the composition of the Roman army. Despite the clarity and precision especially characteristic of Roman forts of the mid- and later first century AD, the origin of their design remains obscure. It is thought that the Romans were influenced by those they conquered, notably the Etruscans and, later, by the Greeks of southern Italy and the Hellenistic kingdoms. Evidently military planning was related to idealised plans for towns, especially new colonies designed to house veterans.

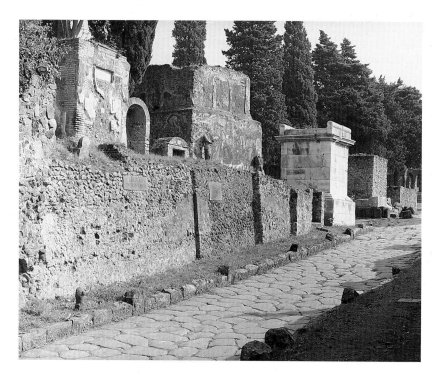

54 The Street of the Tombs outside the city gate of Pompeii.

Memorial tombs

For the wealthy in search of lasting *fama* a good prospect was offered by the monumental tomb. Countless funerary monuments were constructed alongside the roads leading from Rome and provincial cities, most designed to catch the attention of passersby, who were not bound to honour the dead formally by obligations of kinship or service. The lack of any shared core of religious belief in life after death encouraged emphasis upon the individual's achievements in life, and many Roman memorials are redolent with pride in social status and professional achievement. Women were commemorated in idealised fashion, the texts listing their virtues. It is common for Roman funerary texts to give an exact length of their subjects' life, in years, months and even days, especially for those who died before their time (about half the modern expectancy). The size of the grave plot is often specified. Though

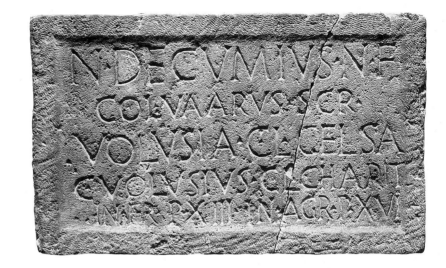

55 (*Above right*) Funerary inscription: the last line of the text records the size of the grave plot as thirteen feet across the front and sixteen feet back (from the road). From a *columbarium* (family tomb) on the Via Appia. 80–50 BC.

56 (*Right*) Sarcophagus decorated with garlands of fruit and flowers. From Ierapetra, Crete. 2nd century AD.

sudden death from what would now be considered trivial disease was common, the Romans were sentimental about family life and mourned their lost children with tender affection.

In the Republic and early Empire cremation was considered the normal rite, inhumation being reserved for a few noble families. Though Augustus had constructed an enormous mausoleum before he became emperor, his cremated remains and those of his descendants were buried inside the great rotunda in simple inscribed chests. Eyebrows were raised when Nero's wife Poppaea was embalmed 'in the manner of foreign kings'.

In the course of the profound Hellenisation of the Empire in the early second century AD, however, the taste grew for burial in marble sarcophagi. At first these were decorated in the manner of earlier cinerary urns with garlands slung from ox- or bull-skulls, a scheme borrowed from monumental altars which reminded the onlooker that the burial container was in Roman law a sacred object. Gradually scenes from Greek myth and drama, often reminiscent of the decoration on late Etruscan cinerary urns and equally unsuited to eternal repose, became very popular. In the third century AD the taste for burial in sarcophagi spread to a much wider spectrum of classes, and individuals were sometimes portrayed as mythological figures.

The distribution of figured sarcophagi in the Roman Empire is remarkably widespread, equalling that of the well-furnished city. This is no coincidence: the discerning 'man of culture', a recurring figure in the public and personal history of the Roman Empire, was essentially an urban phenomenon. Sarcophagi were produced in workshops associated with the major quarries of marble at Carrara (Italy), Penteli and Thasos (Greece), and Proconnesus and Docimaeum (Asia Minor). A host of local workshops (almost one for each river valley in western Asia Minor) copied metropolitan fashions or safeguarded local traditions. As the major market, Rome supported its own school and a distinctive style in burial chests. These

56

59 (*Right*) Wooden coffin lid, hollowed to fit over a mummy. The carved portrait is of an unknown man in Greek dress, whose curly hair is cut in Roman fashion. The cover and mummy were set upright in a shrine provided with doors, which could be opened to reveal the face looking out, as if through a window. The effect would have been similar to that of the freedmen reliefs set into the walls of tombs in early imperial Italy. Made in Egypt about AD 45–55.

60 (*Far right*) Mummy of an unnamed youth. The external bandages are arranged in geometrical patterns. A wooden panel has been inserted in the bandages, on which is painted a portrait of the youth. From Hawara (Fayum, Egypt). Made about AD 100–20.

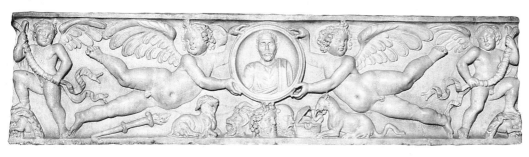

57 Sarcophagus from Rome: portrait of a man set in a medallion supported by flying cupids, with a Bacchic scene below. 3rd century AD.

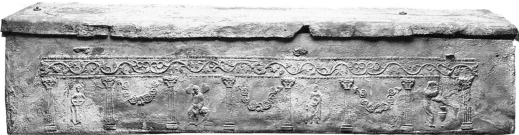

58 Lead coffin decorated with figures of local deities and Psyche, set between columns. From Sidon (Lebanon). 3rd century AD.

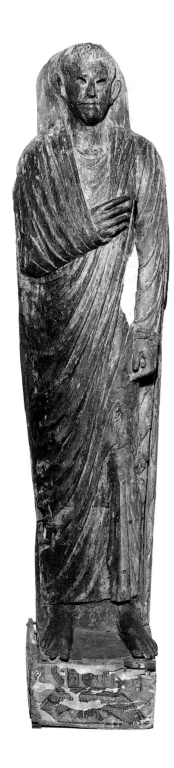

were low and long, designed to fit within an alcove and therefore left undecorated on the back. More personalised than the sarcophagi 57 produced in the Greek east, the chests made at Rome are a fine reflection of an accommodation made between the desire to express an interest in traditional Greek culture and the lack of space in the metropolis for fine tombs.

Some provinces continued local traditions of burial, or adopted minority fashions. In Egypt mummies continued in use, and individuals were buried in wooden coffins, often 59 elaborately painted. Mummy-portraits painted on wood in encaustic (a wax-based medium) offer a poignant glimpse of the individual, 60 exquisitely coiffed and bejewelled, peering from the wraps. Lead coffins found favour in countries with no native marbles, such as Lebanon and Britain. These were decorated 58 with moulded shells and motifs, such as the bead-and-reel or ovolo, copied from architectural ornament. Even lead coffins offered scope for the expression of personal interest in traditional Greek culture: the more sophisticated were decorated with representations of figures such as Psyche, perhaps intended as a reference to loss of life, and with deities both well known and obscure.

The fashion for decorated coffins survived the adoption of Christianity as the official religion of the later Empire. Although the Christian sarcophagi of fourth-century Rome were decorated with motifs of religious significance and sometimes with scenes from the Bible, sculptors frequently adapted figures from pagan repertory. Many pagan sarcophagi with inoffensive decoration, such as lions' heads, were reused for Christian burial or copied for Christian clients. Finally, the grand columnar sarcophagi of second- and third-century Asia Minor, exported to Italy in small numbers in antiquity, remained a source of inspiration for the finest medieval memorials.

49

4 The Romans at home

The houses (*domus*) of rich and powerful Romans were designed and decorated to reflect their position in public life. The architect Vitruvius, writing in the age of Augustus, distinguished various categories of people and their requirements. Rustics, for example, needed only utilitarian storage areas; financiers required a degree of comfort and elegance; lawyers and advocates needed space for receptions, and holders of public office demanded tall vestibules and grand courtyards. For some powerful public figures there was little privacy. It was even Roman custom to keep the front doors of noble houses open, though access to house and patron was in most cases controlled by porters and servants. The wealthy parvenu Trimalchio, the subject of Petronicus' brilliant work, the *Satyricon*, employed a porter dressed in green, with a cherry-red sash, who was observed by guests shelling peas into a silver bowl. However, the emperor Vespasian spent most of his time in Rome in the Gardens of Sallust, while the doors of his palace stood open, and, we are asked to believe, unguarded.

In the morning there took place the formal greeting of clients and associates (*salutatio*). The late Republican and early Imperial *domus* seem expressly designed for this purpose. The clients, waiting on benches provided outside the house, proceeded through the *vestibulum* 61 (entrance hall) into the *atrium* (courtyard), and across to the *alae* (anterooms for secretaries and officials), finally to meet the patron in the *tablinum* (reception room). Friends were allowed even closer access, to dine in the *triclinium* and even to be present at the great man's rising or retirement. Thus Dio Cassius records the emperor Vespasian conversing with intimate friends 'even before dawn, while lying in bed'. Accordingly, Roman houses, much influenced by the grander residences of Hellenistic Greece and Asia Minor, were furnished with suites of reception rooms for the conduct of public affairs and entertainment, the latter more private but by no means limited to the family.

Indeed, it has been observed that the Roman *domus* was no more than a series of decorated spaces, around which were disposed cell-like rooms for more intimate discourse or private use. Such an arrangement does not sound homely but two mitigating factors should be borne in mind: today we see the empty remains of these houses, but they were of course peopled, and different people could use the same space in various ways throughout the day. The second factor is the plentiful evidence for the provision of doors, allowing closure of even the smallest spaces, including stairways. From surviving works of art it is clear that curtains were also a major feature of 63 Roman houses, and could be used to increase privacy.

To meet his social needs and reflect his status the owner of the grander Roman *domus* tended to favour architectural and decorative features associated in Classical and Hellenistic times with public buildings. Thus the so-called 'Egyptian' *oecus* was derived from the basilica, and indeed served a similar public function as

61 (*Far right, top*) View across the *atrium* to the *tablinum*, with the peristyle garden beyond. House of the Faun, Pompeii. 2nd century BC.

62 (*Far right, bottom*) Garden with peristyle at Pompeii.

63 (*Right*) Part of an ivory panel: scene of a confirmation, which takes place in front of a brick arcade. Curtains, here looped back, are provided to screen the archways. Probably made in northern Italy in the 4th or 5th century AD.

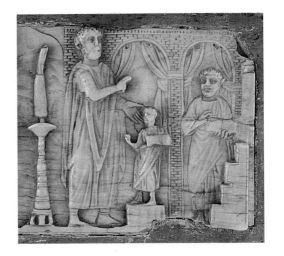

mental decorative features, such as drafted margins to each block, and moulded dados. Painters of the Second Style (90–10 BC), in which vistas were framed by columns, accurately copied architectural decoration, often using supporting figures such as Caryatids or Atlantes. The painted vistas were of landscapes or private gardens. These were clearly inspired by the country villas of the late Republic, themselves an illustration of the triumph of order over brigandage and piracy. The Third Style, introduced at about the beginning of Augustus' reign and lasting to the middle of the first century AD, abandoned rural vistas for equally illusionistic urban picture galleries, using the columns, candelabra, scrolls or rectilinear frames to enhance painted panels. Such panels, complete paintings in their own right, form the bulk of modern collections of Roman wall-painting. Most prestigious among the subjects of the framed panels were mythological scenes, followed by landscapes, still lifes or portraits, the latter often set in round medallions. The

64 (*Above*) Panel from a painted wall: Odysseus resists the Sirens. Third style, 20 BC–AD 20. From Pompeii.

65 (*Right*) Fragmentary wall-painting: maeander pattern painted in perspective. Second style, about 80 BC. From Lanuvium.

a grand reception hall, and the peristyle garden offered a scaled-down version of the Greek *stoa*. Though the surviving archaeological record is biased towards empty rooms, it does seem that the Romans preferred to decorate walls rather than clutter their houses with much furniture. This, too, is perhaps a reflection of the quasi-public function of the Roman *domus*.

Styles in wall-painting were also adapted from the decoration of public buildings. The so-called First Style of Pompeian painting (current from 200 to 80 BC), imitated in stucco relief marble-encrusted walls with monu-

66 Panel from a painted wall in the villa at Boscoreale, near Pompeii: marine landscape, with a man fishing from a bridge, and others in a boat. On the shore is a pavilion with three storeys. Third style, about AD 1–20.

painted walls were well integrated with the layout of the rooms, so that visitors were impressed from a distance.

Mosaic floors were fashionable throughout the Empire. The Romans developed the Hellenistic Greek technique of making patterned floors with *tesserae* (cubes of stone). Gradually coloured floors became fashionable, and by cutting stones, glass and tile into tiny pieces it became possible to make mosaic pictures as detailed as paintings. Mosaicists did not depend upon the steady provision of new material. They fashioned floors from off-cuts, recycling old material, and flourished even in the more difficult economic climate of the late Empire, producing splendid patterns and complex figured scenes. Schools of mosaicists could be found from Carthage north to the English Cotswolds and east to Syrian Antioch and beyond.

Like wall-paintings, mosaics added to the prestige of the house and could indicate, through careful choice of subject, the patron's interests or the function of a particular room. It is likely, then, that the panels in the British Museum collections depicting fish come from *triclinia* (dining-rooms). A *tablinum* (reception room) might have greater pretensions to culture, and thus be decorated with figures of the Muses. Hunting scenes, mythological or drawn from life, were as popular in mosaic as in other media, reflecting an aristocratic style of life. But many mosaics were simply decorative, surely reflecting fashions in textile. Within the room the layout of a mosaic could reflect the disposition of furniture or the way in which the room was used. Thus an *emblema* (central panel) drew attention to the most important point of the room, such as the space before the patron's couch. A divided floor

might indicate the position of a bed within a *cubiculum*.

Even in the less luxurious houses of Pompeii, which were intended more for the entertainment of guests than the conduct of public affairs, there was a marked tendency to provide more space than seems necessary. It appears that the Romans enjoyed the luxury of choice, and the pleasure of moving bedrooms, dining- and reception rooms according to season. Such customs may seem less extravagant given the possibilities, then limited, for heating and cooling rooms; moving one's room was a means of mitigating the effects of the climate, and was thus exploited along with the use of screens, windows, curtains and the like. Textiles had a considerable influence upon wall-paintings in the colder provinces of the western Empire (just as they do upon modern wallpaper).

The wealthy responded to climate on a grander scale. They would own several houses,

67 (*Left*) Mosaic panel: lion taunted and bound by cupids. From Pompeii. About 30 BC–AD 20.

68 (*Right*) Mosaic panel from the floor of a dining-room at Carthage: baskets of fish and flowers. 2nd century AD.

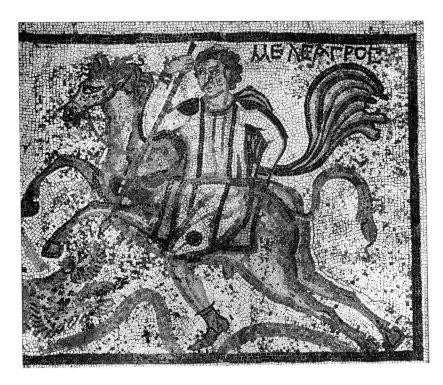

moving from one to another according to the season. They travelled with a large retinue of family, friends and servants. Some houses were hardly inhabited by their owners, though were presumably maintained throughout the year: the famous 'Villa of the Mysteries' at Pompeii, for example, may have been used for partying at the vintage. In the later Republic the seas and countryside were cleansed of pirates and bandits. Rome had grown disagreeably crowded, and it became fashionable to own a country villa with a view. The most luxurious of these were quite palatial, and might include splendid terraced gardens with architectural conceits such as grottoes and fountains. Some villas evidently owned by wealthy Romans were working farms, but even these might proclaim the urban origins of their inhabitants. The late Republican villa at Sette Finestre, near Cosa, is named for the turrets with windows set at intervals in the perimeter walls. Travellers seeing these from the road to the north would glimpse what appeared to be a miniature fortified city.

The most notable seasonal house-dwellers were the emperors themselves. The ruins of imperial residences dot the hills surrounding Rome, Latium and the Bay of Naples. Most spectacular of the surviving palaces is the Villa

69 (*Above*) Panel from the floor of a villa at Halicarnassus (south-west Asia Minor): Meleager hunting. The hero is identified by a Greek inscription. 4th century AD.

70 (*Below*) *Urbs in rure*: artist's impression of the Roman villa at Sette Finestre, near Cosa (Tuscany), as it would have been seen by a traveller on the road to the north.

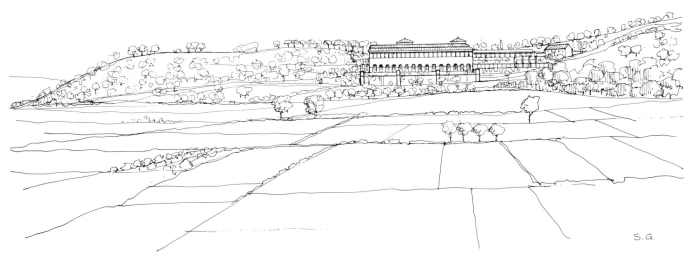

S.G.

71 A set of bronze strigils, used to scrape oil from the body at the gymnasium or baths. This set is decorated with scenes of chariot-racing at the Roman Circus. From Torre Annunziata, near Naples. 2nd century AD.

of Hadrian at Tivoli. Lavishly decorated with Greek and Egyptian sculptures and fanciful buildings, this was no private retreat but a working palace that could accommodate the entire court. Hadrian also built a new pavilion in central Rome in the Gardens of Sallust on the Quirinal Hill.

The Roman port of Ostia offers a glimpse of urban housing of mixed quality. Here were excavated Roman equivalents of modern tenement blocks, subdivided by apartment or even room. In the *insulae* (blocks) of Ostia, as in the more spacious houses of Pompeii and Herculaneum, it was not uncommon for shops to be integrated with residential quarters, occupying a room or a suite of rooms in an advantageous location on the ground floor. No Pompeian houses were provided with private supplies of piped drinking water, though many had wells and cisterns. Unlike the Greeks, wealthy Romans did not bathe at home, but until late antiquity enjoyed convivial baths, segregated by sex.

The pleasures of the table

It seems from surviving accounts that the entertainment of guests at dinner was one of the greatest pleasures of imperial Rome. The passion for dining on the grand scale certainly inspired one of the world's greatest satires on social climbers: the *Satyricon* by Petronius, a courtier of the emperor Nero. Trimalchio's table, of which glimpses are given in the following pages, made a fine joke, but one evidently based upon extravagant contemporary fashions. Roman eating and drinking habits also inspired contemporary art, notably mosaics and painting. Much Roman tableware is of artistic interest and has survived in large quantities from various parts of the Empire, as Roman dining habits spread in the provinces in the course of the first century AD.

In the early Republic the staple food of the Romans was moistened cereal, but in the course of the second century BC this changed to a diet based on bread and wine. The first bakery at Rome is said to have opened in 171 BC. The shift of emphasis is surely the result of contact with the Greeks. The Romans greatly esteemed fish, on which subject they were pedantically snobbish, devising categories and classes of their favourite food. They were also great connoisseurs of wine, favouring the Greek wines of Lesbos and Chios, and developing fine wines in central Italy. It is no accident that the great villas of the late Republic were built in the best wine-producing areas – the Alban Hills, the coast from Sperlonga to Formia, and the fringes of the Bay of Naples. In this period, too, wine was widely exported to the western Mediterranean. Local black-glazed pottery also formed part of the cargo. The acquisition of Sicily and Sardinia allowed new areas for the cultivation of corn, and freed Italy for wine production.

In the early Empire the Italian producers faced competition from the coastal areas of Spain and Gaul. The great agronomists of the

period – Columella is the most famous – came from these provinces. The wines of north-eastern Italy were upgraded to export quality, and were sent east through the Adriatic, while the western vineyards found a new market in Rome. The population had so increased that a wine shortage occurred under Augustus – not that the austere first emperor (favourite wine: Setian, from nearby Latium) paid much attention to the clamour.

The wealthy were clearly aware of the various qualities of wine, and developed a hierarchy of vintages and vineyards akin to modern expertise on the subject. At Trimalchio's dinner 'some glass jars, carefully sealed with gypsum, were brought in, with labels tied round their necks, inscribed "Falernian of Opimius" vintage, 100 years in the bottle.' The poor, on the other hand, drank *posca*, a sour wine diluted with water. In the later second century AD serving soldiers bought *posca* at a fixed low price as part of their rations. Indeed, *posca* became a potent symbol of the common man. It was given to the dying Christ by a Roman soldier holding up a soaked sponge on a pole. The emperor Hadrian showed solidarity with the lads by drinking *posca* on a visit to the troops in Germany. Agricultural slaves were given *lora*, a watered extract of pressed grapes.

To dine late is often seen as a sign of urban sophistication. So it was at Rome, where the evening *cena* (dinner) became the focus of social life. Dinner was taken after a bath. The Romans adopted from the Greeks the custom of dining while propped on cushions on couches. A *triclinium* (dining-room) was so named for the capacity to house three couches, each of which accommodated three reclining diners. These were ranged in order around a low circular table, set at the height of the beds. It was considered bad form for the host to take prime place, as Trimalchio did in Petronius' notorious *grande bouffe*. Sometimes

the table was covered with a cloth; it was cleaned with a heavy woollen rag (Trimalchio's was purple!). Another round table might be provided for wine. Crockery might be kept in a *repositorium* (sideboard); Trimalchio's *repositorium* boasted a donkey of prized Corinthian bronze 'with panniers holding olives, white in one side, black in the other. Two dishes hid the donkey; Trimalchio's name and their weight in silver was engraved on their edges. There were also dormice rolled in honey and poppy-seed, and supported on little bridges soldered to the plate. Then there were hot sausages laid on a silver grill, and beneath the grill damsons and pomegranate seeds.' The dining-room was lit with lamps hung from candelabra. Incense-burners might remove offensive cooking smells.

Dining was a messy affair, as the Romans ate with their fingers. First they washed: 'At last we sat down, and boys from Alexandria poured water cooled with snow over our hands'. The food was pre-cut in the kitchens, and spoons alone appeared at table for liquids. The diners therefore needed napkins, and the frequent use of finger-bowls. All this entailed the presence of servants. The Augustan poet Horace, who considered himself abstemious, had three servants to serve even a modest meal of leeks, chick-peas and fritters. At grand banquets a *nomenclator* (*maître d'hôtel*) took care of the seating arrangements, and a host of specialised slaves were employed for specific tasks.

We have already mentioned the Roman taste for fish. With meat and green vegetables, it was a favoured choice for the first course (*prima cena*). Before this might be served a *gustatio* (appetiser), perhaps comprising eggs, marrow, salad, chicken or exotica such as ostrich. The *gustatio* was accompanied by honeyed or perfumed wine. Following the *prima cena* came the *altera cena*, a course of roast meat (fowl and game were especially

72

72 (*Left*) Bronze lampstand of rustic appearance. The tray from which lamps were suspended is missing. From Torre Annunziata, near Naples. 1st century AD.

73 *Poculum* (cup) decorated with stamps. The painted dedication in archaic Latin is to an unknown deity. From Vulci, Etruria. Made in Rome or south Etruria in the 3rd century BC.

prized). The meal closed with the *secundae mensae*, a dessert of sweets and fruit, fresh or dried. Again, Trimalchio's feast offers a taste of the finale to a spectacular meal:

In came some Spartan hounds, and started running around the table. A tray was brought in with a wild boar of the largest size upon it, with two little baskets woven of palm hanging from his tusks, one full of dry dates and the other of fresh. Round it lay sucking-pigs made of hard cake ... these were for the guests to take away. A large bearded man with bands wound around his legs, and a spangled hunting-coat of damasked silk drew a hunting knife and plunged it into the boar's side. A number of thrushes flew out at the blow. As they fluttered round the dining-room, there were fowlers ready with limed twigs who caught them in a moment ... Then boys came and took the baskets which hung from [the boar's] jaws, and distributed fresh and dry dates to the guests ... (*Sat.* 40)

After the feast came the serious drinking, preceded by a libation to the wine-god Bacchus. Entertainment was often provided in the form of music, dancing and reading aloud, or the less-cultured but much-appreciated game or even gladiatorial fight. Trimalchio loved acrobats, but they bored his guests: 'At last the acrobats came in. A very dull fool stood there with a ladder and made a boy dance from rung to rung, and on the very top to popular music, and then made him hop through burning hoops and pick up a wine-jar with his teeth ...'

It is hardly surprisingly that so sophisticated a cuisine provoked accusations of gluttony, a recurrent theme of early imperial satire. Two emperors died of food poisoning: Claudius ate a dish of deliberately poisoned mushrooms (another delicacy: Trimalchio ordered mushroom spawn from India), and Antoninus Pius consumed a surfeit of Swiss cheese.

Roman tableware

Greed extended to tableware, which could be acquired in terracotta for as little as half an *as*, or for 100,000 *sesterces* for a specially commissioned vessel in precious stone or metal. Fancy tableware could be hired for the occasion: the late first-century poet Martial mocked Calpetanus, who rented gilded vessels to dine wherever he happened to be, even for picnics in the country. The moralist Seneca was most disparaging of contemporary (Neronian) taste. He dined off the family silver, which had been used for generations and was not even signed. But the lie to such claims of modesty is given by the numerous references to collections of plate made by soldiers serving in the east, and by the finds made at Pompeii and Herculaneum, and in Gaul, where hoards of fine silver were buried in times of duress. In the House of the Menander at Pompeii were found a large round two-handled plate (*lanx*), decorated in relief, and a set of sixteen smaller serving dishes in four different sizes. The villa at Boscoreale produced 104 silver plates. Over three hundred types of Roman drinking vessel are known. The original version, a cup without a foot (*poculum*), was made in terracotta or wood. Later versions appeared in metal and glass. The latter constitutes a great Roman contribution to the dinner-party. For the first time, with plain glass widely available, it was possible to drink from a vessel that imparted no distracting taste or sensation. Most drinking cups were shallow, to inhibit drunkenness and to encourage sediment to settle. They never quite lost a religious association, being based upon the vessels used to pour libations to the gods.

Roman pottery, highly durable and found on every excavated site, is particularly well studied, and many centres of manufacture are known. During the Republic these developed beyond the production of black-glazed wares for local markets, and the workshops of Rome

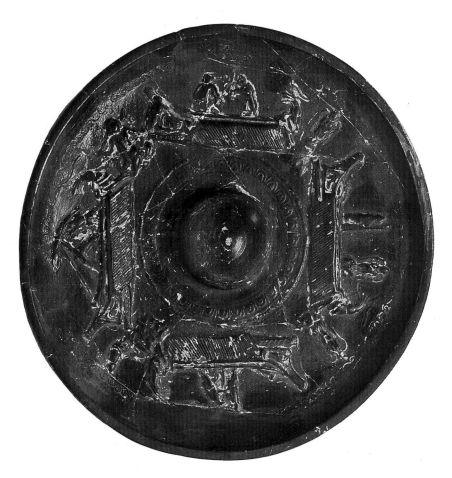

74 Black-glazed *phiale* (dish for pouring libations) decorated with scenes from the *Odyssey*. From Tarquinia, Etruria. Made about 250–180 BC.

the black-glazed ware of Rome, which was exported within Italy to northern Etruria and even to the Adriatic coast, and overseas to Corsica, and the north Mediterranean coast from Liguria to Catalonia. Black-glazed ware from Rome also reached Carthage and its dependent territories in Sicily and Sardinia. These relationships are reflected in the development of a 'triangle of trade' between Rome, Marseilles and Carthage, which brought in its train the development of a harbour for Rome by the mouth of the Tiber at Ostia.

The finest pottery of this period was evidently regarded as of high artistic importance. Numerous surviving makers' marks attest the activity of several workshops apparently manned by a mixture of free men and slaves. Stamped or relief decoration was common for the finer products of Campania and Rome. Decoration in relief reflected contemporary interest in Greek legend and literature. Scenes from the Homeric *Odyssey* were popular, as they were in other media. Figures of Hercules adorned the plates of certain Latin workshops, while dedications to Hercules made at Rome were adorned with a simple painted H. In general the old Greek shapes survived for ritual and votive vessels, such as the *phialai* 74 *mesomophaloi* (shallow bowls with a raised central boss) made at Cales in northern Campania as late as the middle of the first century BC.

In the later third century BC there was a hiatus in pottery production as in other artistic media. The formerly thriving local workshops dwindled in importance at this period, but some time was to elapse before the adoption of models from the Greek east, stimulated by the appearance of Greek works of art and fine craftsmanship in Roman triumphs (see p.11). Typical of the earlier second century BC are the thin-walled vases related not to contemporary 75 Greek products but to the Celtic pottery of central Europe. The second century saw the

achieved dominance over their competitors by the second century BC. Designs of high quality and originality were produced in regional workshops in central and southern Italy throughout the third century BC. Potters in Etruria adapted Greek shapes and local relief decoration. A good example of a regional type 73 is offered by the *pocula* of southern Etruria and Rome. The shape of these small votive cups was of local origin, but the painted decoration was borrowed from the workshops of Tarentum in south-east Italy. The products of the third-century BC workshops enjoyed only a limited distribution, even within southern Italy. A significant exception to this rule is

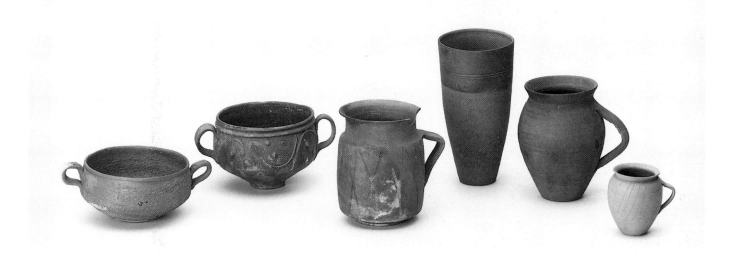

75 Thin-walled drinking cups and a beaker made in Italy and found in Italy, Sardinia and the Balearic Islands. 1st century AD.

growth of two new types of black-glazed vessel known to modern scholars by the uninspired names of Campana A and B. These vessels were much simpler in form than their predecessors of the early third century. Made on the island of Ischia and at Naples of non-calcareous paste obtained on Ischia, most Campana A vases were of open shape ideal for stacking, and offered little scope for more than indefinitely repeated patterns. Such vessels were clearly intended as merchandise for exchange, and were exported in large numbers. With no stamps referring to owners or craftsmen, they are thought to be the standardised products of large workshops staffed by slaves. Production lasted from about 200 to 40 BC. The vessels were evidently shipped with produce, and it is significant that both Campana A and the more refined Campana B, intended for the Italian market, were made in the wine-growing areas of the Bay of Naples and north Etruria.

In the course of the first century BC, the thin-walled cups of Celtic inspiration were decorated with a slip of contrasting colour to that of the fabric of the vessel. Some vessels of this type, notably the early imperial 'Aco' beakers and 'Sarius' cups, named for their potters, 76 were made in moulds and decorated in relief. By this stage the makers of such cups were evidently influenced by a new kind of fine pottery, first made at Arezzo in Tuscany and called Arretine after its place of manufacture. The rise of Arretine ware represents something of a break with earlier traditions. Though some eastern forms were adopted, especially for vessels of higher quality and religious significance, the Greek element in Italian pottery of the last three centuries BC had mostly been supplied by the Greek communities of southern Italy. The earliest plain ware made at Arezzo was unexceptional, being clearly developed from local black-glazed wares. But following Octavian's victory over Antony at Actium the Arretine workshops started to produce pottery decorated in relief. As in so many other aspects of Augustan art, the inspiration for much of the decoration was Classical Athens. In the manner of painted Greek vases of the Classical period, some of

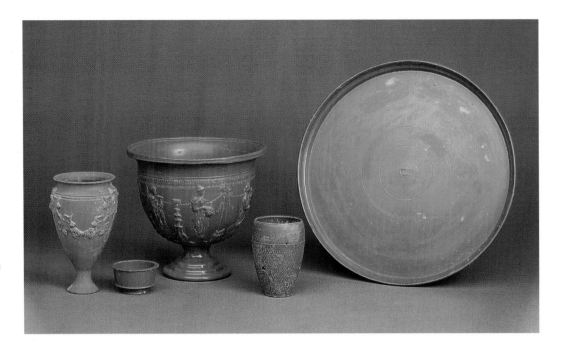

76 Early red-glossed ware: (*left*) cup from Pergamum, about 125–75 BC. The other vessels are Arretine ware except for the beaker, made by the potter Sarius. All these are from Italy and made in the late 1st century BC and early 1st century AD.

the figures were identified by name, no doubt as a sign of the source of inspiration, but perhaps also intended as a practical aid to the Roman connoisseur, to help him pick his way through the finer points of Greek mythology and literature. Classical Greek shapes were also revived, such as the *krater* (mixing-bowl for wine) and the *kantharos* (stemmed drinking cup). It is hardly surprising to find Greek names in the stamps placed in the moulds used to make decorated vessels. The names are thought to identify slaves or freedmen of Greek origin, who worked for the Roman owners of workshops. It is not out of the question that some workshops were owned by Greeks.

Some of the non-figured decoration is of later Greek inspiration, the kind of floral and vegetal motifs found on contemporary architecture and vessels of precious metal. It is likely that Arretine pottery was developed to respond to the demand for a cheaper alternative to silverware. Variety of decoration was

achieved by preparing individual wooden or clay stamps (*poinçons*), to impress a motif into the mould in which the pot was thrown on the wheel. Thus the decorative scheme, which might comprise as many as thirty stamps, was unique to the mould. Further embellishment might be added freehand with a stylus. The other dominant characteristic of Roman fine pottery is a hard surface in the form of a glossy slip (Arretine and later Gaulish wares), a matt slip (African and eastern wares of the later Empire) or, less frequently, a glaze (usually lead-based). Slips were made from a suspension of particles of clay in water; to achieve a gloss finer particles were used. The finish was achieved by the use of sophisticated controls over firing in the kiln.

The marketing of Arretine pottery followed earlier patterns of export. Like that of the earlier black-glazed pottery from Campania, Arretine was associated with the growing wine trade of the late Republic and early

Empire. But at this period of expanding military occupation and governmental reform the expatriate Roman customer was dominant, and operating in a much wider area of northern and western Europe. One manufacturer, Gnaeus Ateius, is known to have set up workshops in Pisa and Lyons, as well as at Arezzo. Early finds of Arretine ware (and indeed of other fine tablewares in metal and glass) may be associated with the deployment of Roman legions north of the Alps. It is almost certain that the Arretine pottery found in the Rhineland was made at Lyons. Many of these vessels were the property of serving soldiers and officials.

As provincials became reconciled to the long-term prospect of Roman rule and military presence on the frontiers, local workshops were established in southern and then in central France and in Germany. These supplied not only the army and civilian officials but also local people who had adopted Roman customs. The earliest products of the southern Gaulish workshop at La Graufesenque were of similar quality to their Arretine predecessors, though their decoration was more crowded and consisted of simpler motifs. These products were even exported from Gaul to Italy: an unopened case of decorated bowls was found in the ashes of Pompeii. Brown colour-coated wares were made throughout the western Empire as an alternative to the red-glossed products.

In the early second century the centre of red-glossed pottery production moved north to the Auvergne, where innovative craftsmen had developed a larger repertoire of higher quality than that of the later work at La Graufesenque. Mythological and hunting scenes became popular with the revival of interest in Greece under Hadrian. Workshops were set up in east Gaul and Germany. The

77 Red-glossed and marbled bowls and cups made in southern and central Gaul and in northern Italy. 1st century AD.

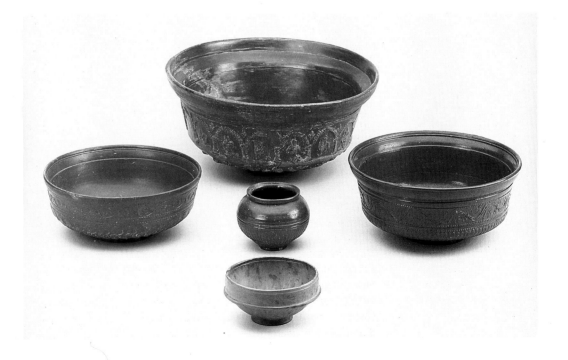

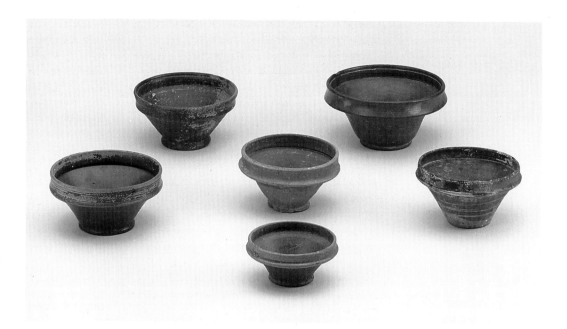

78 (*Right*) Drinking-cups made in Italy, Gaul and Asia Minor, showing how uniform and widespread were some shapes of pottery vessels within the Roman Empire. 1st century AD.

79 (*Below*) A vase in the form of a grotesque male head. Made in Cnidus (south-west Asia Minor) between AD 60 and 120. Probably exported to Italy.

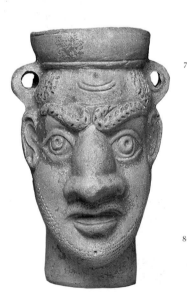

success of red-glazed pottery led to the poaching of designs. Inevitably a decline set in; the later designs were poorly reproduced and lacked vitality. Many local workshops in Britain, Spain and Italy produced their own versions of red-glossed ware. Some plain forms were standardised throughout the Empire: 'Haltern' cups, named for one of the sites in which they were found, are known from all over the Empire, and the distinctive shape was copied in local fabrics.

In the third century AD the declining European pottery producers, their homelands disrupted by the contest for power at the end of the preceding century, faced overwhelming competition from new centres of imperial interest in north Africa and the eastern Mediterranean. From the late first century AD onwards workshops in Tunisia had produced a distinctive red-slipped ware with a large variety of shapes often inspired by the forms of metal vessels. Many of these were plain, but some had moulded or appliqué figures around the rim or the body. In the third century AD these workshops became the main suppliers of red-slipped ware to the provinces bordering the Mediterranean. The potters (or more likely their customers) were very conservative in their taste, and red-slipped wares were produced with very little change until the seventh century AD.

One potter, Navigius, (*c.* AD 300) copied for the African workshops the relief-decorated wine-bottles, made from the first to the third centuries AD at Cnidus in Asia Minor. Such bottles belonged to a large family of jugs and grotesque or portrait head-vases widely marketed in the eastern Mediterranean. The complex forms were made in plaster moulds, and imitated figures in terracotta or metal. More pedestrian red-slipped wares were made in various centres at Çandarlı (Pergamum), Phocaea (north of Ephesus), Cyprus and in Egypt, where lively painted wares were pro-

duced in late antiquity. Roman red wares fell out of use in the northern provinces, which lay largely beyond the reach of Mediterranean suppliers, and were supplanted by a variety of local products, often engagingly decorated in paint or barbotine.

Glass had long been manufactured in the Near East and in Greece, mostly in the form of brilliantly coloured small vessels intended to hold perfume or oil. A few sets of glass tableware are known from Mesopotamia and from the Greek world, but it was not until the Roman Empire that plain glass tableware became relatively common. The small vessels of pre-Roman date were mostly made by applying molten glass or glass rods to a pre-formed core. The latter, made of mud tempered with grass and coated with ground limestone, was usually fixed to a metal rod which could safely be dipped into a vat of molten glass. Trails of coloured glass might be applied to the surface, which was then reheated and marvered (rolled smooth). The rod and core were removed, and the neck and base of the vessel added to the body. Larger vessels of open shape were cast in open or closed moulds, or shaped over a former. Typical cast products, such as bowls and plates, were finished

by grinding the inner and outer surfaces.

In the course of the first century BC a new technique of glass-making emerged, that of blowing vessels on the end of a metal pipe. This technological advance liberated glass-makers from the need to follow the shapes of vessels made in stone, pottery or metal. The advance was in processing alone; the raw material – pure sand, with added soda and lime – remained the same throughout antiquity. By the end of the first century AD blown glass was evidently relatively cheap, for it is found in significant quantities in domestic and military sites.

The successful production of blown-glass vessels required a furnace capable of heating glass under very carefully controlled conditions to the very high temperatures necessary for blowing by mouth, and a second chamber in which the vessels could cool very gradually to avoid fracture. Glass without mineral additives was bluish-green, a colour given by the iron present in all sand. Roman glass-makers added metal oxides to their finer products to alter the colour. Glass was melted in clay crucibles (fireproof vessels); these were probably fired in the same wood or charcoal-heated furnace. It was common practice to add to the

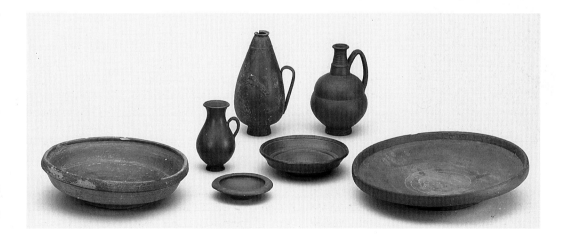

80 Red-slipped tableware made in Africa Proconsularis (Tunisia) and Egypt. Late 1st to the 7th century AD.

mixture in the crucible broken glass from malformed vessels or old pots. Known as 'cullet', this mixture was relatively pure as it had already been processed, and it was further refined before melting by heating to burn off impurities. Molten glass was removed from the furnace with a blowing iron (a hollow rod at least four feet long). Rotating it continuously, the glass-maker moved the iron to a block, where the molten glass collected on its end was rolled and blown into the desired shape. Two glass-makers were needed to make vessels with stems, feet and handles, as the blown body had to be kept rotating while more glass was gathered for the additions. Glass could be blown freehand or into a mould of clay or wood. Window panes were probably cast in wooden moulds, at least in the early Empire.

Vessels were decorated by working the glass while it was still hot. Glass-makers used pincers to make raised knobs and ridges and indents in the sides of a vessel. Trails and blobs were popular; these could be marvered (rolled) flush to the body or left protruding from the surface. Glass could also be painted or engraved with a wheel. The latter techniques were executed cold, not necessarily at the foundry.

In the first century BC, when glass-blowing was invented, the most important market for glass, especially tableware, lay in Italy. The traditional eastern centres of production continued to flourish, but new centres of manufacture of glass were also developed close to the main markets in Rome and around the Bay of Naples. Aquileia in north-east Italy and Cologne, on the Rhine, were also important centres, because of both the high quality of locally available sand and their convenience as supply centres for the Roman army. Technical development in glass manufacture was very rapid. The most extraordinary achievements, in terms of size and complexity of design, were made in the century between

50 BC and AD 50.

That glass was then prized is clear from the evidence of contemporary paintings, which occasionally show individuals using glass vessels where one might expect metal, and scenes of fruit shown to advantage through clear glass bowls. 'You may forgive me', claimed Trimalchio, 'if I say that personally I prefer glass [to Corinthian bronze]; glass at least does not smell. If it were not so breakable I should prefer it to gold, as it is so cheap.' Glass was to become as common as fine pottery, and is found in approximately similar quantities on archaeological sites, even in frontier provinces such as Britain. Like Roman red ware, it is indicative of Roman presence in marginal areas. Plain glass could be made anywhere with appropriate raw materials. But although plain glass vessels became widely available, the Romans never lost their taste for intricately decorated glassware. Some of the products of the later Empire are so convoluted as to be virtually unusable, and were surely intended as ornament or signs of status to be deposited in tombs.

Bronze was also used for tableware, for

81 (*Above*) Cylindrical box, cast in blue glass. From near Rome. AD 1–50.

82 (*Below*) Bronze dish decorated with a scene of Scylla devouring the companions of Odysseus. The handle is ancient, but does not belong to the dish. From Boscoreale, near Pompeii. Early 1st century AD.

83 Roman glass: (*left to right*) blown blue jar, from Pozzuoli, near Naples, about AD 50; blown and cut cup, decorated with an Egyptian scene, 3rd century AD; flask with snake-thread decoration, from a grave at Koblenz, Rhineland, 3rd century AD; glass beaker decorated with almond-shaped bosses, from Syria, AD 50–100; mould-blown flask in the form of a bunch of grapes, later 1st or 2nd century AD.

serving food and for the preparation of food and drink. Bronze vessels could be elaborately decorated with the figured scenes popular in other media (as with pottery, the *Odyssey* was a favourite source). All metal vessels needed to be kept clean and untarnished. Ancient bronze was golden brown, not green: that colour results from patina acquired after burial. Wealthy households employed specialised servants to clean metal tableware and prevent it from tarnishing.

For the very wealthy tableware made of luxury materials was available: there was once a former Roman consul who paid 70,000 *sesterces* for a cup made of fluorspar. He was said to be so fond of it that he gnawed the cup's rim! The Elder Pliny has several such tales of the lure of luxurious tableware and the road to imbecility, if not moral ruin. Like gluttony, the passion for collecting fine plate invited the jibes of moralists and satirists. A passion for fine tableware goes with an appetite for good food, and there can be no doubt from the surviving archaeological evidence that the Roman Empire saw the growth of a surprisingly widespread taste for vessels of metal or rare stone. The excessive, the extraordinary and the outrageous found their way into contemporary literature, but the very rich family might be expected to own a silver *ministerium*

84 (*Above*) Fluorspar *kantharos* (goblet). 1st century AD.

85 (*Below*) Part of a silver *ministerium* (table service), buried at Arcisate, near Como (northern Italy) about 75 BC: (*left to right*) bowl for mixing wine, spatula, ladle, jug and strainer.

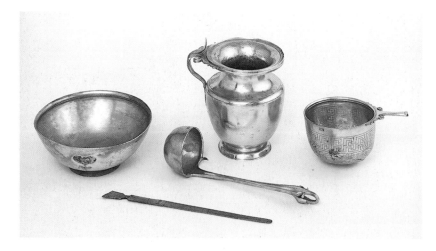

(drinking and dinner service) sufficient for themselves and for invited friends. Since washing was of fundamental importance to diners who ate with their fingers, finger-bowls and mirrors often featured in the dinner service. Sets of toilet articles are sometimes found in 85 tombs; these were for the most part not from *ministeria*, but belonged to well-to-do women.

Decorated cups from a *ministerium* made an ideal present for a barbarian chieftain: the cups from Welwyn (Hertfordshire) are a good example of the genre. Other elements of an early service were found at Arcisate in northern Italy; these comprised a mixing-bowl, strainer, jug and ladle. The Romans extracted silver from galena (lead sulphide) ores. The high quality of Roman silver plate (95–7 per cent, with copper as the main alloy) was maintained throughout the Empire. Handles were often less pure, as they bore the brunt of hard use. Most silver vessels of the early Empire were formed of two skins soldered together, of which the outer carried the decoration, hammered or punched from the inside (*repoussé*), while the inner served as a smooth lining. As with Augustan fine pottery, the decoration might be improved by freehand engraving, and shapes of drinking vessels popular in Classical Greece were revived. The decoration of early Roman silver might reflect the literary interests of those wealthy enough to afford it for the *triclinium*; two silver cups of 86 probably eastern origin are thought to represent scenes from a lost play by Sophocles. Two cups surviving from the villa discovered at Boscoreale, near Pompeii, show Augustus receiving the submission of barbarians and his successor Tiberius celebrating a triumph; these were most probably intended as presents from the emperor to a loyal official or member of his court. As in contemporary painting, there was also a fashion for reproducing the 86 natural world in this highly refined medium.

About the middle of the first century AD

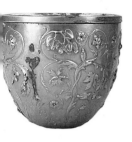
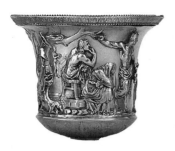
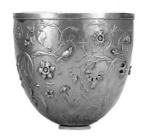

86 (*Above*) Three early imperial silver cups: (*centre*) decorated with scenes from a tragedy by the classical Greek dramatist Sophocles; (*left and right*) with scrolls of foliage resembling those on the Altar of Augustan Peace.

there was a sudden change in technique from labour-intensive *repoussé* and engraved work to casting and cutting in heavier alloys. The unusually speedy change is recorded by the Elder Pliny, and is matched by archaeological evidence. We may see here some reaction on the part of silversmiths to the growing demand for silver plate.

Molten silver ingots and melted fragments of vessels were cast to a convenient shape, further hammered into shape on a prepared surface, then reheated and worked repeatedly. Vessels were hammered in spirals, working from a point at the centre of the exterior. Lathes were used to achieve a delicate finish. Some forms, such as some of the small cups in the hoard deposited in the third century AD at Chaourse (France), were directly cast in their definitive shape. The 'lost-wax' technique was used to cast elaborately decorated handles. A mould was made around a wax model, and the wax melted until it flowed out, leaving a void to be filled by the molten metal. Decoration of the surface of the vessel often took the form of simply turned or chased concentric rings. Punches were often used, notably to make the beaded borders so characteristic of later Roman vessels. *Niello* was very popular. This was a powdered black metallic sulphide, of the same composition as the vessel it was to decorate. The compound was inlaid in under-cut areas on a deliberately roughened surface. *Niello* was often contrasted with gilding,

87 (*Right*) Silver *ministerium*, (table service) buried at Chaourse (France) in the 3rd century AD. The service includes (*background*) three large serving platters; (*foreground, left to right*) a pepper-pot in the form of a dwarf, a washing-bowl, decorative statuettes, four sets of drinking cups, a mixing-bowl, a ladle, a serving jug, a small serving plate, side-plates, small cups, flanged bowls, a second mixing-bowl and a washing-bowl, and a mirror.

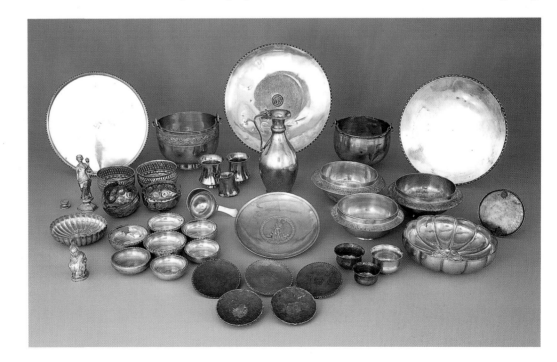

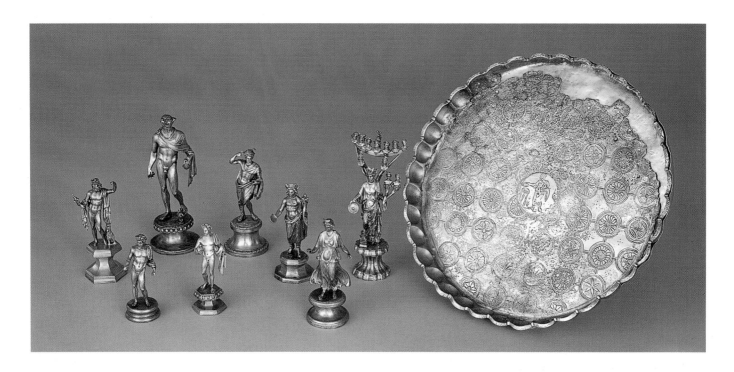

88 A hoard of silver buried at Mâcon (France) after AD 260: a statuette of Jupiter, four figures of the messenger-god Mercury, a Genius, the goddess Luna, and the protective goddess Tutela, with a headdress decorated with busts of gods representing the days of the week. The dish is known from 18th-century drawings to belong to the hoard.

which until the third century AD was applied as gold leaf, attached by rivets or wrapped in place, or glued or inlaid like *niello*. Very thin gold leaf could be beaten into shape and then lightly heated to fuse with the surface. From the third century AD until the nineteenth century gold leaf was commonly heated with pure mercury, which acted as an adhesive. Both methods of fusion are known to have been used for silver statuettes and vessels in the Mâcon and Chaourse hoards. Pepper was introduced in the first century AD, and, once the Romans had got used to its strange taste, never lost its popularity. A silver dwarf from the hoard deposited at Chaourse is thought to have served as a pepper-pot.

Much of our knowledge of Roman silver is derived from the hoards of plate buried during troubled times in the Empire's history. France is particularly rich in such hoards. These are unfortunately vulnerable to thieves and speculators, many hoards remain incomplete, their original purpose unclear. The hoard of silver statuettes, plate and coins (the last lost) from Mâcon (Burgundy) may have come from a sanctuary. The hoard found at Beaurains (Arras) was apparently the property of a senior officer in the Roman army, who had taken part in the reconquest of Britain under Maximinian (AD 296). As a reward for long service he had received coins and a fine candelabrum, the latter no doubt intended to illuminate the dinner-table. These imperial gifts are of exceptional quality, but the jewellery from the hoard is second-rate, and was probably accumulated by his family. However, the significance of the hoard is clear enough: on the north-west frontier of the Roman Empire, as in today's troubled regions, gold and silver were seen as possessions of lasting value in an insecure and radically changing world.

Further reading

I. M. Barton (ed.), *Roman Public Buildings* (Exeter 1989).

M. Henig (ed.), *An Introduction to Roman Art* (Oxford 1983).

J. J. Pollitt, *The Art of Rome c. 753 BC–AD 337. Sources and Documents* (2nd edn, Cambridge 1983).

T. W. Potter, *Roman Italy* (London 1987).

F. Sear, *Roman Architecture* (London 1982).

R. R. R. Smith, *Hellenistic Royal Portraits* (Oxford 1988).

D. E. Strong, *Roman Art* (Harmondsworth 1980).

Y. Thebert, 'Vie privée et architecture domestique en Afrique Romaine', in (eds.) P. Ariès and G. Duby, *Histoire de la vie privée* (Paris 1985).

S. Walker, *Memorials to the Roman Dead* (London 1985).

S. Walker and A. Burnett, *The Image of Augustus* (London 1981).

J. B. Ward-Perkins, *Roman Imperial Architecture* (Harmondsworth 1981).

P. Zanker, *The Power of Images in the Age of Augustus*, trans. A. Shapiro (Ann Arbor Michigan, 1988).

List of British Museum objects illustrated and where they can be seen

All of the objects listed are in the Department of Greek and Roman Antiquities, unless otherwise indicated by the following prefixes:

CM Coins and Medals
EA Egyptian Antiquities
MLA Medieval and Later Antiquities
PRB Prehistoric and Romano-British Antiquities
WAA Western Asiatic Antiquities

The figures in brackets after the room number refer to the numbers of the cases.

Front cover Gems 3577 Room 70 (12)
Inside front cover GR 1946.4–23.1 Room 85
Title page Painting 37 Room 70 (7)
Back cover Sculpture 1381 Room 70

2 Bronze 2561 Room 70 (12)
3 Terracotta D 625 Room 69 (17)
4 Vase G 161 Room 70 (5)
5 Sculpture 2300 Room 83
10 Sculpture 1666–7 Room 84
11 Sculpture 1754 Room 15
12 Gems 4036 Room 70 (11)
13 Sculpture 1874 Room 84
14 Sculpture 1755 Room 13
15 Lamp Q 957 Room 70 (12)
16 Sculpture 2206 Room 15
17 Sculpture 1988 Room 83
18 Sculpture 2048 Room 83
21 Sculpture 1966 Room 70
22 a CM BMCRR 4207 Room 70 (6)
 c GR Gem 1190 Room 70 (6)
23 CM BMCRR Sicily 7 Room 70 (6)
25 a CM BMCRR 4135 Room 70 (6)
 b CM BMC Augustus 599 Room 70 (7)
 c CM BMC 7 Room 70 (7)
 d CM BMC Augustus 702 Room 70 (7)
26 Sculpture 1885; Sculpture 1880 Room 70
27 1954.12–14.1 Room 70
28 Sculpture 1890 Room 70
29 Jewellery 2870 Room 70 (30)
30 a CM BMCRR Gaul 103 Room 70 (7)
 b CM 1954.10–9.1 Room 69 (mezzanine)
31 PRB Loan, Kent County Council Room 40
32 1911.9–1.1 Room 70 (1)
33 Sculpture 1883 Room 70
34 1983.12–29.1 Room 70 (5)
35 Bronze 867; CM BMC Augustus 443 Room 70 (14)
36 a Gem 1975 Room 70 (7)
 b Gem 3593 Room 70 (7)
 c 1987.7–28.1 Room 70 (18)
 d Gem 3611 Room 70 (30)
 e Gem 2016 Room 70 (30)
37 MLA Early Christian 304 Room 41 (17)
38 WAA 105204 Room 57
39 EA 29772 Room 62
41 a Ring 1469 Room 70 (5)
 b Ring 208 Room 70 (30)
 c 1872.6–4.835 Room 70 (30)
44 Sculpture 1152 Room 70
 Sculpture 1155 Room 70
45 CIL XI 3073; 1867.5–8.67 Room 70
48 CIL III 6580; 1946.2–6.1 Room 78
49 WAA 125025 Room 70
51 Loan, Winchester City Museum Room 70
52 1923.1–16.1 Room 70 (17)
55 CIL VI 1862; 1973.1–8.1 Room 70
56 Sculpture 2324 Room 83
57 Sculpture 2323 Room 84
58 1921.12–13.1 Room 70 (29)
59 EA 55022 Room 60 (41)
60 EA 13595 Room 60 (44)
63 MLA Ivories 9; Early Christian 293 Room 41 (18)
65 Painting 13 Room 70 (5)
64 Painting 27 Room 70 (10)
66 Painting 19 Room 70 (10)
67 Mosaic 1 Room 70 (10)
68 Mosaic 4 Room 70
69 Mosaic 51A Room 70
71 Bronze 865 Room 70 (9)
72 Bronze 2547 Room 70 (9)
73 Vases F 604 Room 70 (5)
74 1919.6–20.1 Room 70 (5)
75 1856.12–23.362; 1888.2–23.6; 1856.12–23.347; 1873.8–20.330; 1856.12–23.354; 1888.2–23.4 Room 70 (13)
76 Vase L 35; Vase L 136; Vase L 54; Vase M 1; Vase L 123 Room 70 (15)
77 Vase M 5; Vase L 138; Vase M 76; Vase M 125; Vase M 4 Room 70 (15)
78 1981.12–18.2; 1856.12–23.366; 1857.1–6.7; 1868.6–20.263; Vase L 48; 1859.12–26.327 Room 70 (15)
80 EA 1929.10–16.132; 1856.12–26.558; Vase L 50; GR 1972.9–27.1; GR 1920.11–18.25; GR 1814.7–4.676; MLA 1928.4–13.10 Room 70 (15)
79 1814.7–4.301 Room 70 (22)
81 1873.8–20.427 Room 70 (16)
82 Bronze 882 Room 70 (9)
83 Glass 989; Glass 14; 1984.7–16.1; Glass 373; Glass 1201 Room 70 (16)
84 1974.4–19.1 Room 70 (12)
85 Silver 126–130 Room 70 (5)
86 1960.2–1.1; 1960.2–1.3 Room 70 (12)
87 Silver 144–182 Room 70 (26)
88 Silver 27–35 Room 70 (25)

Index

Figures in bold italics refer to illustrations

Actium, battle of 13, 25, 61
Aeschines, portrait of *19*
Agrippina the Younger *36*
Alexander the Great 5, 11–13, 20, 24, 29, *inside back cover*
Alexandria 20, 29, 58
Antiochus III of Syria 10, *25*
Antonia the Younger *19*
Antoninus Pius 29, 44–5, 59
Antoninus, Publius Vedius 37, 44
Antonius (Mark Antony) 13–14, 61
Arcisate (N. Italy) 68, *85*
Aristides (painter) 12
Asia Minor 5, 11, 13, 22, 38, 41, 44, 48–50, 64
Athens 5, 11, 13–14, 25, 29, 39, 41, 61
 Temple of Olympian Zeus *9*, 13, 15
Augustus *front cover*, 5, 13–14, 18–20, 22, *25*, 26–7, 30–2, *32*, 33–4, *35*, 37–9, 41–3, 48, 50, 52, 58, 68

baths 38, 45, 57, *71*
Bay of Naples 56–7, 61, 66
beards 28–9
Beaurains (Arras) 70
Bithynia 44
Boscoreale, villa at 59, *66*, 68, *70*
Britain 6, 21, 45, 49, *53*, 64, 66, 70
bronze, tableware 66–7, *82*

candelabrum 58, 70, *72*
Carthage 53, 60
Cato the Elder 14
Cephisodotus 12
Cerdo, Marcus Cossutius *10*
Chaourse 69–70, *87*
children, portraits of 37
Cicero 13
Classical Greece, influence of 5, 15, *16*, 19, 21–2, 29, 33, *37*, 38–9, 40, 51–2, 62, 68, 76, *86*
Claudius 19, 41, *44*, 59
Cleopatra 13
Clytie *13*, 19
Cnidus 64, *79*
coffin, lead 49, *58*
 wooden 49, *59*
Cologne 66
Constantine I 26, 28, 40
Corinth 12, 29
Corinthian bronze 13, 58, 66
Cossutius, Decimus 15

court fashions, adoption of 5, 29–30
cremation 11, 48
Cyprus 5, 12, 30, 64

damnatio memoriae 30
decor, sense of 5, 22
deditio 9, 10
deities, freedmen
 portrayed as *inside front cover*, 34
Delphi 10, 11, 13
dining habits 57–8, 68
Domitian 31

Egypt 5, 7, 13, 30–1, *33*, 34, 36, *39*, 49, *52*, *59*, *60*, 64, *80*
elephants *4*, 9
Ephesus 37, 44–5, 64
Etruscan art 8
 pottery *4*, 60, 61
Etruscans, influence of 38, 46, 48

Flamininus, Lucius Quinctius 10, 29, *30*
fluorspar 67, *84*
forts 5, 38, 46, *53*
freedmen-reliefs 27, *27*
fulcra 2

Gaius (Caligula) 33
Gaius Caesar *26*
Gallienus 28, *29*
Gaul 57, 59, 63, 70
Germanicus Caesar 31, *33*
Germany 10, 58, 63
glass, cameo 19
 cast box *81*
 jars 58
 perfume flasks 65
 tableware 6, 59, 63, 65–6, *83*
glass-blowing 65
Greece 5, 10–14, 19, 21–2, 29, 37, 41, 43, 48, 50, 63, 65
Greek art (booty) 5, 8, 10–14, 22, 60
Greek artists at Rome 5, 11, 14

Hadrian 5, 8, 15, 21–2, 28–9, 33, 38, 45, 57–8, 63, *back cover*
 Villa at Tivoli of *16*, 57
Hannibal 9, 10
Hellenistic world, influence of 5, 8, 14, *14*, 24, 25, 28–9, 38, 46, 51–3, 57, 60, 62
Herculaneum 57, 59
Herodes Atticus 37, 45, *51*
houses, access to 50, *61*
 circulation 50, *63*
 influence of public building on 50, *62*
 inhabited seasonally 54, 56

imperial motifs, use of *15*, 19, 20
 by modern regimes 38
inscriptions 5, 30, 37, 39, 41–3, *45*–*50*, 52
 funerary 47, *55*
insulae 57
Ischia 61
Isthmia 13, 29
Italy *Map 2*, 5, 8–11, *10*, 13, *15*, *17*, 27, 33, 48–9, 57–8, 60, 63–4, 66, 68, *78*

jewellery 34, 36, *36*–*40*, 70
 portraits on 36, *41*
Julius Caesar 13, 25–6, *25*, 29, 30, 38–9, *41*, *44*

lamps *15*, 58
Latium 56, 58
Lebanon 49, *58*
luxuria 11
Lyons 63
Lysippus *5*, 10, 12

Mâcon 70, *88*
marble trade *17*, *18*, 22, 38, 43, 48
Marcellus, Marcus Claudius 9, 10, 22, 24
Marcus Aurelius 40
Marseilles 13, 60
masks, ancestral 24
Maximian 30
Menodotus 15
Meroë (Sudan) 31, *32*
Metellus 'Macedonicus', Quintus Caecilius 11–12, 15
Middle East (Levant) 5–7, 34, 65
Mithradates VI of Pontus 13
mosaics 53–5, *67*–*9*
mummy 49, *60*
 portrait 39, 49, *60*
Mummius, Lucius 11–13

Naples 29, 61
Navigius 64
Nero 29, *30*, 48, 57
North Africa 6, 7, 10, *80*

obelisk *8*, 13
Octavian 13, 25, *25*, 26, 29, *30*, 61
Odyssey 60, 67, *74*, *82*
Olympia 11, 13, 17, 37, 41
Ostia 57, 60

pallium 32
Palmyra, funerary reliefs from 34, *38*
 inscription from 43, *49*
Pasiteles 15–16
Paullus, Lucius Aemilius 11
Pausanias 14, 22, 41
Pergamum 12, 26, 64

Pericles 41, 44
Petronius 50, 57
Pheidias 11
Philip *29*
Philip V of Macedon 10
Pisistratus 15
plaster models 16
Pliny the Elder 9, 11, 67, 69
Pliny the Younger 31, 44
Plutarch 9, 41
poculum 59, 60, *73*
pointing machine, use of 16
Polybius 12, 24, 48
Polyclitus *11*, 17–18, 26
Pompeii *title page*, 52, 54, *54*, 56, 57, 59, *61*–*2*, 63, *64*, 68
Pompey 13–14, *23*, 24–5
Portland Vase *12a, b*, 19
pottery, 'Aco' beaker 61
 African red-slipped 62, 64, *80*
 Arretine 61–3, *76*
 black-glazed 57, 59, 60–2, *73*–*4*
 brown colour-coated 63
 Campana 61
 eastern sigillata 62, 64
 Gaulish red-slipped 62–3, *77*
 grotesque 64, *79*
 'Sarius' cups 61, *76*
 thin-walled 60–1, *75*
Projecta, casket of 34, *37*
Puteoli (Pozzuoli) 16, *83*
Pyrrhus of Epirus 9

Restio, Gaius Antius *22*, 24
road-building *Map 2*, 9, 38
Rome *1*, 5, *7*–*8*, 8–17, *14*, *16*, 27–8, 38–40, 47–8, 56–60, *57*, 66
 Ara Pacis 20, 37
 Arches of Constantine and Titus *43*
 Campus Martius 13
 Circus Maximus 13, 32
 Column of Trajan 42, *46*
 Colosseum *contents page*, 38, *43*
 Curia Julia 13
 Forum of Augustus *1*, 14, 38–40
 Forum of Caesar 38
 Forum Romanum 30, 32, 38, *43*
 Gardens of Sallust 50, 57
 Porticus Metelli 12–13
 Porticus Octaviae 7
 Temple of Capitoline Jupiter 13
 Temple of Ceres 12
 Temple of Fortuna 11
 Temple of Juno Regina 12
 Temple of Jupiter Stator 12, 15
 Temple of Mars Ultor *1*, 39
 Temple of Venus Genetrix 13
 Theatre of Pompey 14

Via Appia 11, 55
Romulus 39

salutatio 50
sarcophagi *5*–*6*, 11, 48–9, *49*, 56–7
 Christian 49
Sardinia 57, 60
Scipio, Lucius Cornelius 'Asiaticus' 10–11
Scipio, Lucius Cornelius 'Barbatus' *6*, 11
Scipios, Tomb of 11
Seneca 59
Sicily 5, 8–9, 13, 57, 60
silver, tableware 62–3, 67–70, *85*–*8*
 technique of working 68–9
 toilet articles 68
southern Italy, Greek cities in 5, 8–9, 13, 15, 46, 60–1
Spain 13, 57, 64
'Spinario' *14*, 19
Statues, bronze 12, 15–17, 31, *32*, 34, 39–40
 gold and ivory 11
 ivory 14–15
 marble *10*–*11*, 13–14, 16–17, *17*–*18*, 22
 painted 17
 set into buildings 5, 21–2, 37, 39, 43, *50*
 silver 30, 70, *88*
 support of marble 17
 terracotta 11, 14
 wooden 11, 14, 22
stola 33, *36*
Sulla, Lucius Cornelius 13
Syracuse 9

Tarentum 9, 10, 13, 60
Tiber 13, 60
Tiberius Caesar *26*, *35*, 68
Timarchides, family of 15
toga 32–3, *34*, 45
town-planning 38, 46
Trajan 37, 44
Trimalchio 50, 57–9, 66
triumphal parades *3*, 8–9, 11, 13–14, 60

Vespasian 27, *28*, 50
villas, late Republican 52, 56–7, *70*
Vitruvius 50

wall-painting, styles of *title page*, 52, 64–6
Westmacott Youth *11*, 17
wine 14, 57–8, 61–2
women, dress of 33, *36*
 hairstyle of 34, *36*
 memorials to 47